ARTISTS' LONDON

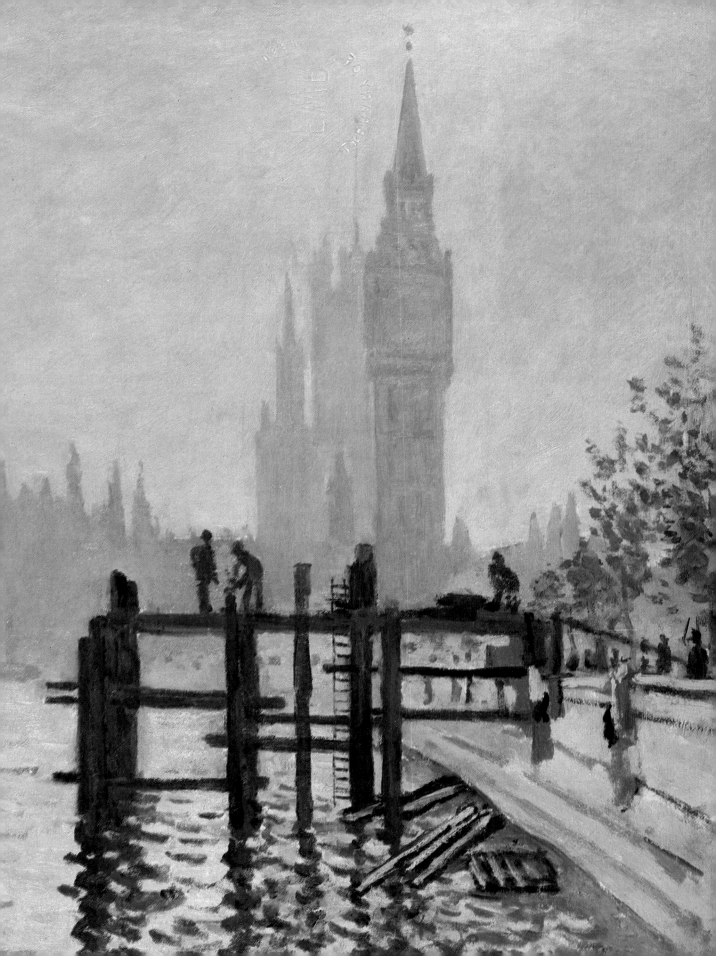

ARTISTS' LONDON

DAVID PIPER

NEW YORK
OXFORD UNIVERSITY PRESS
1982

FRONTISPIECE **Claude Monet,** *The Thames and Westminster* (detail), 1871. Monet's earliest Thames view was painted during his first visit to London whither he had fled in the autumn of 1870 to escape the Franco-Prussian War.

First published in Great Britain in 1982 by
George Weidenfeld and Nicolson Limited

First published in the United States in 1982 by
Oxford University Press Inc.

Printed in Italy

Library of Congress Catalogue Card Number 82–081324
ISBN 0–19–520392–5

CONTENTS

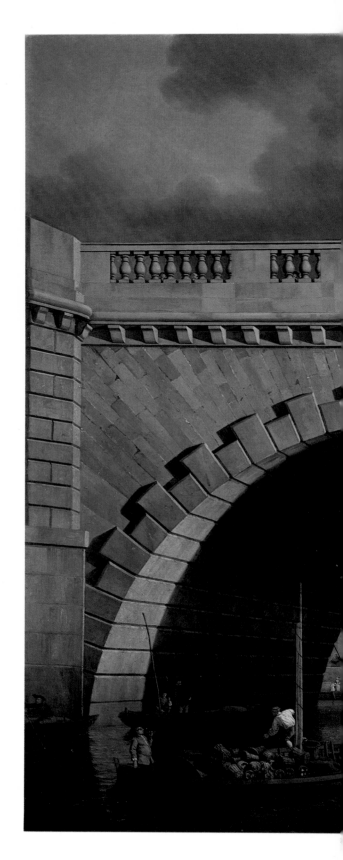

Samuel Scott, *An Arch of Westminster Bridge, c.* 1750. The river front of Whitehall, including the York Buildings and the wooden water tower, can be seen framed by either the third or fourth arch of Westminster Bridge. The erection of the lamps on the turrets of the piers shows that the construction of the bridge was nearing completion. It was replaced by a new bridge designed by Thomas Page in 1862.

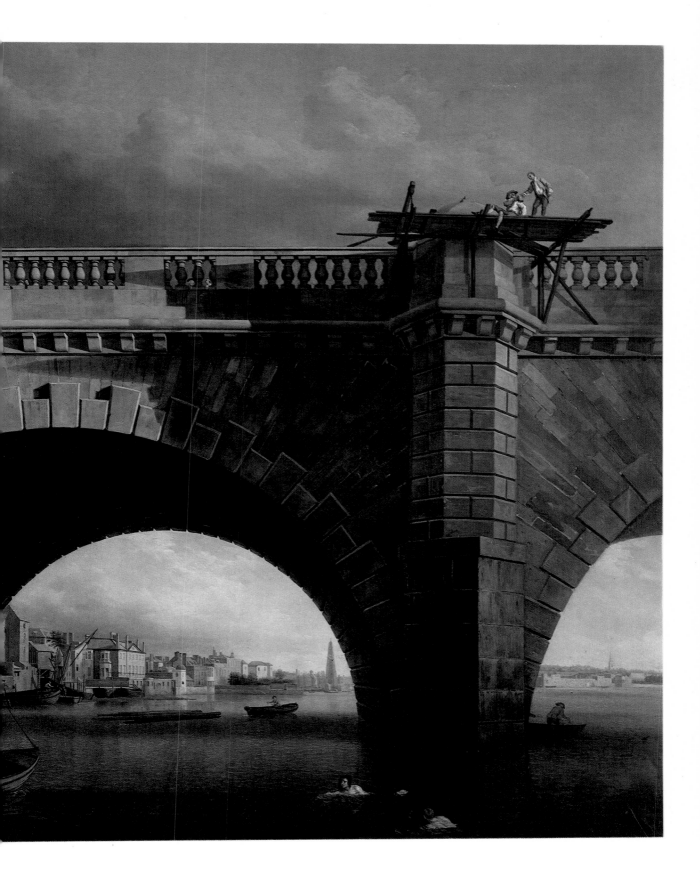

INTRODUCTION

'AT PRESENT', NOTED OSCAR WILDE in the late 1880s, 'people see fogs, not because there are fogs, but because poets and painters have taught them the mysterious loveliness of such effects. There may have been fogs for centuries in London. I daresay there were. But no one saw them, and so we do not know anything about them. They did not exist till Art had invented them.'

Fogs there certainly were. No doubt the Thames itself, even before London began to cluster on its northern bank, was often if not constantly shrouded in dense mist steaming on its unembanked flood and the marshes of its tidal estuary. But the apparently unique flavour of the London fog when Wilde was celebrating it was due to the preponderance of coal smoke in its recipe; on that, many travellers commented from the early eighteenth century onwards, but never on any quality of loveliness in it. The first writer to celebrate London fog – in prose, but with a cumulative eloquence that makes many poets seem prosaic – was Charles Dickens, in passages such as that in *Our Mutual Friend* or the overture to *Bleak House.* Dickens however was not orchestrating loveliness, rather a Stygian gloom. The American poet, James Russell Lowell, in London on a November day in 1888, wrote that he liked fogs: 'they leave the imagination so wholly to herself, or just giving her a jog now and then . . . the natural poesy of London that makes the familiar strange'. But he noted also 'an ominous feel about it to which I never get wonted, as of the Last Day'.

The painter that Wilde must have had in mind was Whistler, his contemporary, neighbour and rival as arch-impresario of Chelsea ('My Chelsea', Whistler frequently said). The lyric loveliness that Whistler evoked from river mists or dusks glimmering with faint lights across the water was his and, as Wilde claims, in a sense did not exist before. The French historian Taine, when he visited London in 1859, was appalled and spurred to an apocalyptic dirge almost as resonant as Dickens's:

> When the Romans landed here they must have thought themselves in Homer's inferno, in the land of the Cimmerians. The vast space which, in the south, lies between earth and heaven, is missing, here, to the seeking eye; no more air, nothing but the flowing fog. In this livid smoke, objects are no more than phantoms and nature looks like a bad drawing in charcoal which someone has smudged with his sleeve.

Gustave Doré, *Bluegate Fields* from *London: A Pilgrimage*, 1872, by Blanchard Jerrold and Gustave Doré. '... in the densely-packed haunts of poverty and crime – in the hideous tenements stacked far and wide, round such institutions as the Bluegate Fields Ragged Schools in Shadwell [in Stepney] – there are hundreds who have never had the chance to escape to comfort and virtuous courses. ...'

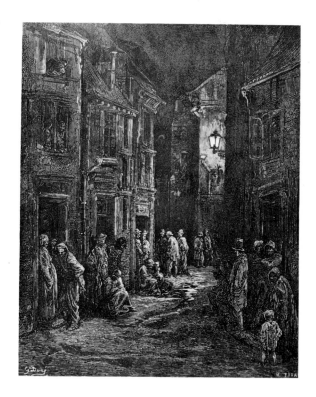

This simile might suggest a crude pastiche of a Whistler nocturne, but the artist whose vision of London in its teeming murk corresponds most nearly to Dickens's or Taine's was the latter's countryman, Gustave Doré, in illustrations that might have been made for James Thomson's poem of *The City of Dreadful Night.*

The very different Londons that Whistler and Doré saw or created have, in a hundred years or less, all but vanished to become nostalgic visions of a city that is no more and perhaps never was. Here is Ambrose Silk, discoursing in Evelyn Waugh's *Put Out More Flags*: 'The decline of England ... dates from the day we abandoned coal fuel ... We used to live in a fog, the splendid, luminous, tawny fogs of our early childhood. The golden aura of the Golden Age. ... We designed a city which was meant to be seen in fog.' Waugh was writing in 1942 when electricity and oil were already replacing coal: 'The fog lifts, the world sees us as we are, and worse still, we see ourselves as we are.' That was even before the Clean Air Act of 1956 which banned the smoke from the traditional 'dirty' coal fire for ever (even if only, as is the way with technological progress, to discover that the pollution effects of oil-burning were just as lethal). On a cool, clear day – an early morning in early spring – you can stand on Westminster Bridge, as

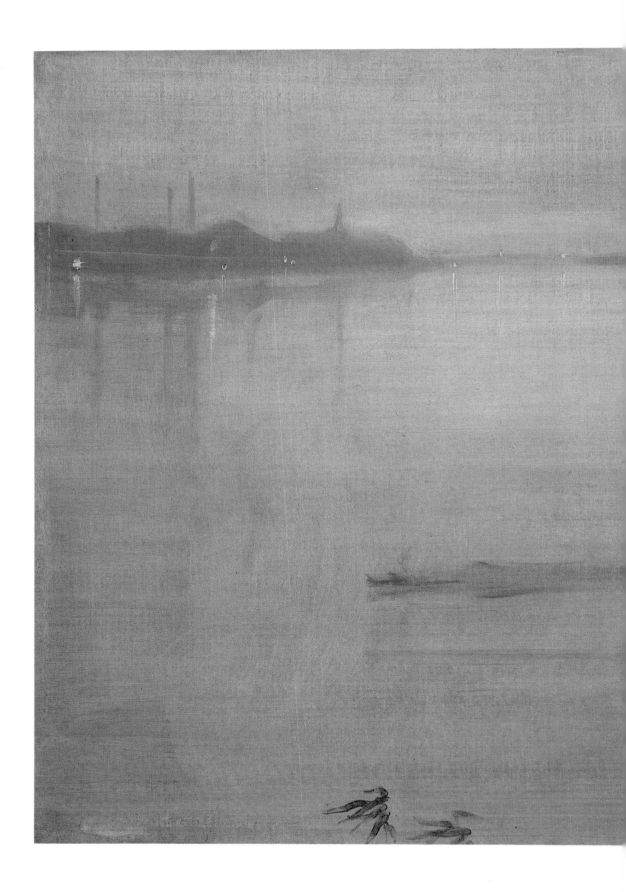

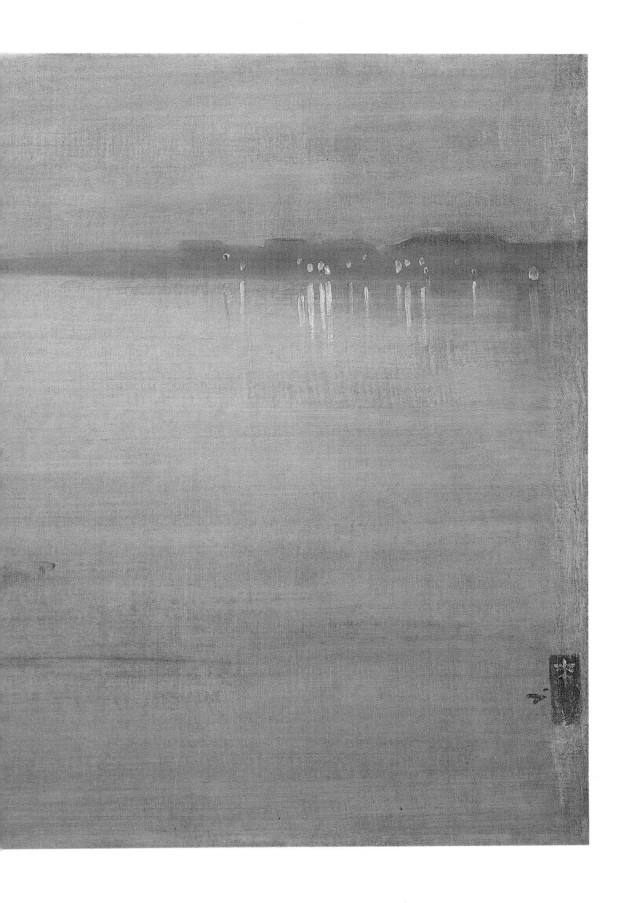

Wordsworth once did, and see London almost as clear and sharp as he did, though whether what you see will convince you that still 'Earth has not anything to show more fair' is another matter, following the rape of London's skyline by the tower blocks of post-war developers.

But that is to anticipate. The theme of this book is drawn from the changing visions of London recorded by the artists who have surveyed it through the centuries. The images of London that they distilled from the sum of that ever-changing city have depended on diverse factors. These include the purpose for which each view was made; the artistic conventions of the time; the medium employed – line, watercolour, or oil-paint; the personality of the artist (including in that term also craftsman) as expressed by the mechanical competence of his hand as well as by the originality and intensity of his imagination. The most memorable images are those in which competence and imagination match each other in high degree, but imagination was not a quality which interested the artists' clients to begin with, or indeed when what was wanted was a factual record: a map. Topography ('detailed description, representation on map etc., of natural and artificial features of a town, district, etc.') would be denied by some purists as qualifying as a branch of art, anyway of 'high' or 'fine' art, precisely because by definition it offered no scope for the exercise of the imagination, rooted in prose as is a catalogue. Nevertheless, as we shall see, some artists, whose given task was no doubt to transcribe with the most faithful literalness possible the likeness of the city, succeeded albeit involuntarily in transcending the limitations imposed upon them.

PREVIOUS PAGES **J. McNeill Whistler,** *Nocturne: Blue and Silver – Cremorne Lights,* 1872. The painting shows the Thames at Chelsea, seen perhaps from Battersea Bridge, with the Battersea factories on the left and the Cremorne Pleasure Gardens on the right. A contemporary critic observed that it showed 'with exquisite gradations and perfect truth one of those lovely effects of dimly illuminated morning mists on the Thames which nature evidently intended Mr Whistler to paint'.

THE MIDDLE AGES

FOR THE FIRST THOUSAND YEARS of London's history no visual record of any
kind remains. The early British settlement on London's site had been recognized
by the Romans as the inevitable one for the establishment of central authority;
it offered a firm gravel base for building at the first point in the marshes of the
Thames estuary where it was possible both for the river to be bridged and a
major port to be sustained, serving the sea routes to the Continent, the crucial
internal waterway of the Thames, and the radiating web of roads by which the
Romans held down their dominion from AD 43 onwards. A bridge was 'thrown
over', as the Romans loved to do, only a few yards east of the present London
Bridge, and the roads duly spoked south, west and north from the hub of
London across Britain.

Archaeologists exhume laboriously the remains of successive strata of
London's history: the visitor, with the aid of a little imagination, can read it
perhaps most vividly in the dusty crypt of the Church of All Hallows, Barking,
just above the Tower of London. Beneath a patch of paved floor, where once
Roman feet trod, excavations revealed a layer of black ash – the mark of the
British Queen Boadicea who in AD 60 turned on the Roman conquerors and
sacked the town, burning it into the soil. The paving speaks of the Roman
revival, as do traces near All Hallows, of the wall with which the Romans girt
Londinium, the greatest city in their Western Empire. A Roman tombstone and
other fragments bear witness to Roman decay into the Dark Ages: London
threatened by Saxons, sacked by the Danes, revived by the great British King
Alfred in the 880s, sacked again by the Danes in the tenth century. In the crypt
of All Hallows the rough stones of a Saxon church of around 700 are still
visible, as are later relics that bring you into the tenth or eleventh centuries. But
as to what the buildings, the environment, the living city to which these
fragments belonged, looked like in their prime, history is silent. The table-top
reconstructions of London – Roman, Saxon, Viking – that children love in
museums all have in common the enchanting unreality of a fairy story into
which unwholesome smells, the noise of anger and of grief, do not intrude, and
in which death does not prevail.

Mediaeval art was notoriously concerned with the life hereafter rather than
with life on earth and the mortal physical reality of men and their earthly

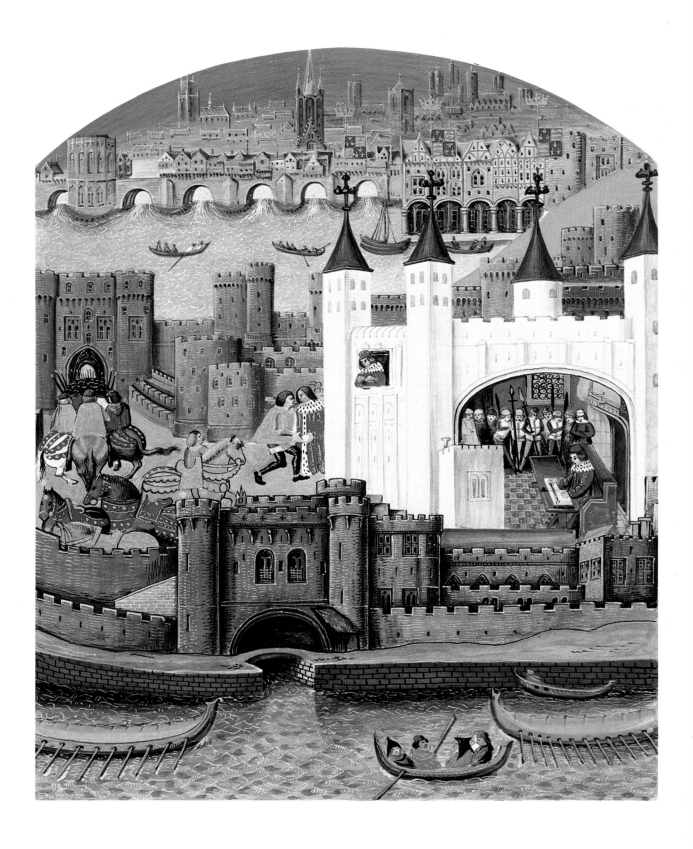

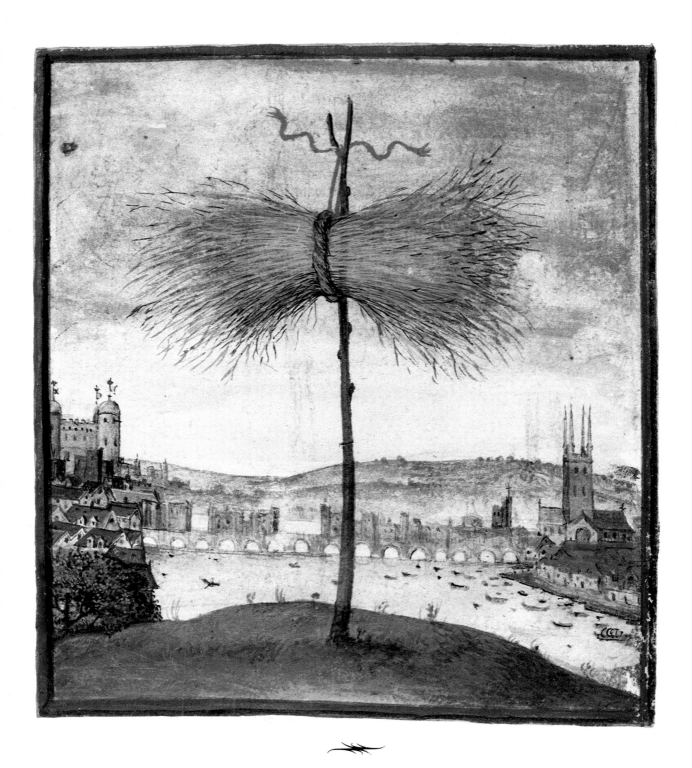

LEFT *Charles d'Orléans in the Tower of London* from a Flemish edition of his poems, *c.* 1500. Captured at the battle of Agincourt in 1415, d'Orléans spent twenty-five years in the Tower, writing the poems which earned him the reputation of being the greatest of the French courtly poets.

ABOVE **Richard Garth,** *London Bridge with the Tower of London and Southwark Cathedral,* 1575. Southwark Cathedral, founded as the Augustinian Priory of St Mary Overy in 1106, was heavily restored in the nineteenth century. In the foreground is a beacon.

possessions. A certain unchanging element of the human make-up must have been interested in the establishment of where one's property ended and that of a neighbour began, definable nowadays by precisely surveyed and measured estate plans, drawn to scale: by maps. Without them, possibilities for disagreement or conflict are obviously seriously enhanced, whether on a national scale or that of a smallholder. Early plans or maps however, even if they existed, have not survived, and do not in fact appear until the sixteenth century after the Roman foundation of London.

The first and fallible, almost token, elements of London that emerge from the Dark Ages are outlines drawn as if by a child round a 'think' of a place; round nothing so vague and vast as a town or city but an element in its totality. Thus the first sight of a London building occurs happily in the earliest and most vivid of English strip-cartoons (though essentially, I suppose, French or at least Norman, as all the best Englishmen were to be for the next few centuries) – the Bayeux Tapestry, which unrolls the drama of King Harold's succession to Edward the Confessor, and the subsequent invasion and occupation of England by the Normans, led by William I, the Conqueror, in 1066. One scene records for the first time one of those solemn royal funeral processions that have provided majestic spectacle in London through the centuries. The shrouded body of Edward the Confessor is carried on a richly embroidered bier to Westminster Abbey. The Abbey had been consecrated on 28 December 1065, an event that seems to be saluted by the hand of God pointing from a cloud above, even while an artisan puts the finishing touch, fixing the weathercock. Edward had died barely ten days later, and was buried on 6 January 1066. The

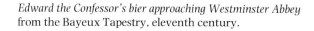

Edward the Confessor's bier approaching Westminster Abbey
from the Bayeux Tapestry, eleventh century.

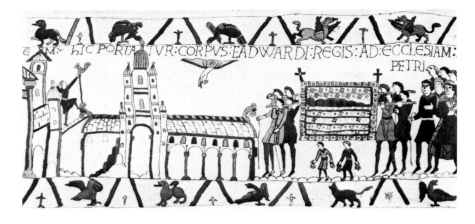

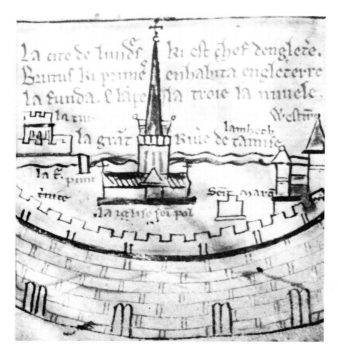

Abbey was later entirely rebuilt, but the structure outlined schematically in the Tapestry indicates, albeit in charmingly wobbly freshness, a Romanesque-style building of scale and grandeur, incorporating, it seems from the very scanty knowledge that has come down to us of Edward's Abbey, apse, nave and central tower.

In the rare illustrations that survive of London for the next four hundred years or so, artists usually indicated London by the outline of one or more of its principal features, as an emblem or symbol standing for the whole. At this stage London was very much two cities: to the east the City of London proper was still contained, though spilling out in ever more uncontrollable fashion, by the great wall that the Romans had built first and the Middle Ages consolidated; to the west, two miles away up river, was Westminster, whither Edward the Confessor had translated the prime royal palace from the City. The identifying symbols for the City were the Tower of London, Old St Paul's Cathedral, and sometimes the Roman Wall; for Westminster, the Abbey and later Westminster Palace, with the turrets of St Stephen's Chapel (site of the future Houses of Parliament) and Westminster Hall. Common to both the City and Westminster was the Thames, the great joint highway of communicating traffic.

So London is condensed by that ingenious and lively chronicler and illustrator, Matthew Paris, in an itinerary illustrating a papal envoy's journey across Europe to offer the crown of Sicily to Richard of Cornwall in 1252. In the centre, the great steeple of Old St Paul's nails London in place; from left to right

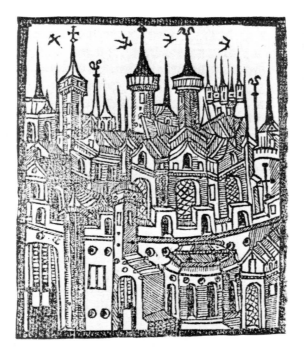

View of London from Wynkyn de Worde's *Cronycle of Englande*, 1497. This woodcut is the earliest printed image of London, though with its lack of any specific aspect it could equally well be of any city.

behind St Paul's, the Tower, the river (with London Bridge), and Westminster. The whole is girt by London Wall in which four of the gates are shown and named, though Westminster was never within the precinct of the walled city. Elsewhere in the same manuscript is a more specific image of Westminster Abbey, apparently as it was after Henry III's rebuilding. Rare glimpses, tantalizingly summary, are all one can hope for at this date, though also from the thirteenth century there is a grand evocation, still fairly condensed, of the majestic Gothic elevation of Old St Paul's on a seal of the cathedral (p. 17).

More than two centuries later, in what seems to be the earliest printed image of London – a woodcut in Wynkyn de Worde's edition of the *Cronycle of Englande*, (1497) – it is clear that the old convention of a cluster of towers, spires or keep within a defensive wall serves to stand for any city. Here is a fine medley of turrets and spires, the topmost three crowned with a cross, a ball and weathercock, with four black birds a-flying in the white sky, but there is no element recognizable as specifically London's. The picture needs its involvement in the text, or the label of London's name, as in the slightly later view from Richard Pynson's version of the *Cronycle* (1510), though there the Thames, or a river, is at least indicated.

In astonishing contrast to such generalities there comes the most famous of all early images of London, the brilliant vision of the poet Charles d'Orléans in

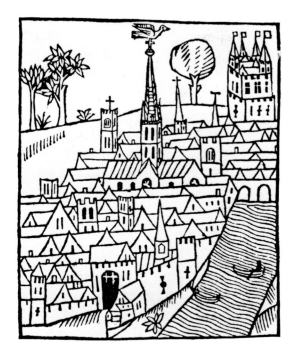

View of London from Richard Pynson's *Cronycle of Englande*, 1510. In a later edition of the *Cronycle* a woodcut of the city is identified by name.

his captivity in the Tower of London (p. 14). As far as d'Orléans is concerned, the account is retrospective: he was taken prisoner by the English at Agincourt and spent twenty-five years in the Tower. D'Orléans died in 1465, but the setting here however is of London as it was in about 1500, when a Flemish artist living in the city illuminated this manuscript of d'Orléans' poems for Henry VII. The poet is seen twice within, seated busily writing poems in spite of the unfriendly presence of his captors, and, above, leaning sadly from his window and his captivity ('*Priez pour paix, le vrai trésor de joie* ...'). Although gutted, as it were, to allow the poet to be seen in full, his abode is clearly the White Tower with its former sharp pointed turret-roofs which by 1543 were replaced by cupolas. In front, very recognizably, there is Traitors' Gate giving on to the Thames, and behind the White Tower, the other fortifications of the complex; beyond that a vividly detailed rendering of London Bridge, with the towers and spires of London in the background. The composition compresses its components with no concern for literal accuracy, and the scale of the figures, greatly exaggerated in relation to the architecture, is still in the medieval tradition. But with the naturalistic observation of the architecture, the precise rendering of the horses along the bridge, even the movement of the water, together with some degree of perspective in the recession into the city beyond the bridge, we are in the Renaissance, and London comes alive.

THE SIXTEENTH CENTURY

THOUGH THE FAITHFUL TOPOGRAPHY OF CITIES was only established as a popular artistic convention in the sixteenth century, it was anticipated by certain qualities in the vividly precise settings of the miniatures by the Limbourg brothers in about 1416, as in the famous *Très Riches Heures* of the Duc de Berry. A little later Jacopo Bellini was recording the canalscape in Venice. Full city portraits begin to emerge in the woodcuts in B. von Breydenbach's *Pilgrimage to the Holy Land* (published in Mainz in 1486), which were done by an artist, Erhard Reuwick, from Utrecht. Thence there developed gradually the 'long city view', of which the best known monument is Braun and Hogenberg's great publication *Civitates orbis terrarum* (1572–1618). One of the contributors to that was Joris Hoefnagel, to whom we shall come in a moment.

The earliest exponent of the long city view in England, Anthonis van den Wyngaerde from Brussels, arrived a little earlier. His personal history is obscure, but it is likely that he came to England in connection with the visit of Philip II of Spain in 1557, though his view of London is sometimes dated as early as 1543. It could have been intended for a never-completed publication of capital cities in Philip's great Empire: he also worked for Philip in the Low Countries, Spain and Italy. In his drawings certain themes were established that continued to attract artists until the eighteenth century and even later. The long city view is generally taken from a bird's-eye angle, if generally a fairly low and raking one. This offers the artist the longest view while at the same time allowing him to preserve the individual likeness of the fronts of the buildings in the near distance. The bird's-eye view remained popular for a very long time, both for engravers and painters. Wyngaerde also realized that his most profitable foreground was inevitably the River Thames, which enabled him, from his imaginary viewpoint as if in a helicopter over the south bank looking north, to distance himself satisfactorily from his main subject: the river frontage with the city stretching back northwards from its banks to the country hills of Hampstead and Highgate. Much of what was most important in London building stood in or near the river frontage for the simple reason that the river was the main road for traffic. So the river, with its space of water, its long vistas, its high and open skies, was to prove the favourite stage for the spectacle that artists from Canaletto to Turner and Monet – even to Kokoschka – would

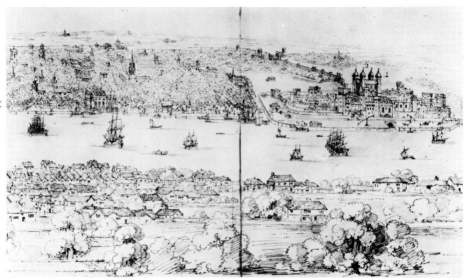

Anthonis van den Wyngaerde, *The Tower of London, c. 1555.* Wyngaerde was the first exponent of the 'long view' tradition of city portraits to visit Britain. His drawings of the north bank of the Thames record several buildings of religious foundations which were gradually disappearing following the Reformation.

conjure up from London's mundane business.

Another subject that Wyngaerde took which, if it did not sustain so long a popularity as the Thames itself, nevertheless continued in favour until the early eighteenth century, was the palaces that the English monarchy had erected like staging posts along the royal route of the river – Greenwich, Whitehall, Richmond, Hampton Court, and as far as Windsor. Portraits of palaces would be found to be excellent wall furniture by the rising bourgeoisie no less than by courtiers: in January 1669 Pepys had the Dutch landscape specialist, Danckerts, measure up the panels in his dining room so that he could paint four palaces to fit them – Whitehall, Hampton Court, Greenwich and Windsor. (Later, somewhat disloyally, Pepys changed his mind about Windsor and had a view of Rome instead, though no doubt to indicate the owner's cultural sympathies, not his popish ones.)

Wyngaerde was a better draughtsman than a mere topographer or portraitist of places, for although closely concerned with the detail of the likeness, he had a sensitive, nervous line and a sure feeling for space – qualities that tell perhaps most evidently in the freedom offered him by the view over fields in the foreground, across the broad expanse of Thames water to the spiky turrets of Greenwich Palace. The river is lively with ships, and the pen-work is vital but sure. He is a worthy herald of Hollar. However, the main body of the city that he records is still confined to the north bank, from the Tower and the City in its walls in the east to Westminster in the west, with the fantastic picturesque of London Bridge clad in houses, its central gateway bedizened with the heads of traitors, as prominent as it was to remain in the memories of most London visitors until the houses came down in the eighteenth century.

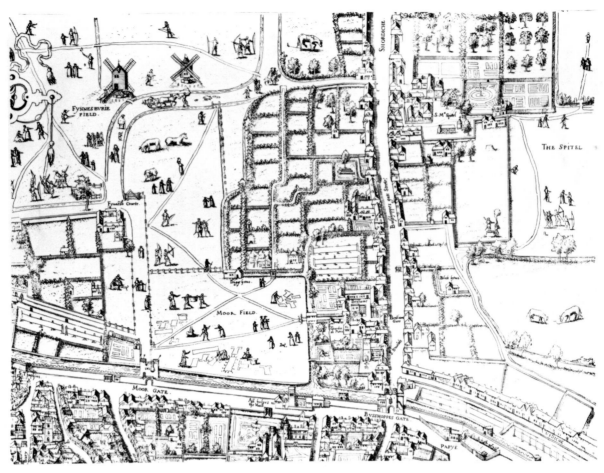

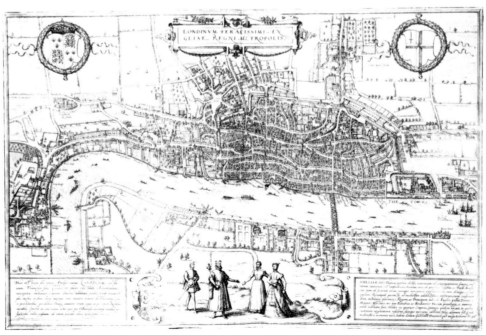

LEFT ABOVE *Finsbury and Moorfields, c.* 1559. One of twenty sheets, by an unknown cartographer, which together made up the earliest printed map of London. The two areas, lying just outside the City walls, were used by Tudor Londoners for pasturing cattle and rural past-times such as archery – activities which are shown on the map.

LEFT BELOW **G. Braun and F. Hogenberg**, *Map of London* (2nd edition), 1574. A famous map, for the German atlas of European cities, *Civitates orbis terrarum* (1572–1618), which shows how the City walls no longer constrained Tudor London.

RIGHT **British School**, *Unknown Man* (detail), *c.* 1595–1600. In the background of this portrait of a melancholic young man there is a view of the Thames, part of the City and the White Tower.

The bird's-eye view could also serve in somewhat paradoxical conjunction with the accurate survey of the ground required by a map, and so it did in one of the most remarkable maps of London ever made, sometime in the 1550s. This was in twenty sheets, but no complete version survives. The two-dimensional mapping of the roads and properties is apparently fairly precise, but superimposed upon it is a three-dimensional isometric projection not only of the buildings but of the inhabitants (impossibly large in scale) about their daily business. One surviving sheet shows Finsbury, the City still fairly comprehensively retained within its walls, with gates that could still be closed (those at Moorgate and Bishopsgate shown here). The well-known map by Braun and Hogenberg, though published later, in 1572, must be based on a survey of much the same date, as Old St Paul's still has the slender soaring spire that was destroyed in 1561. This map has in fact been associated with Wyngaerde though the style is very different. The four elegant figures in the foreground, poised as if on a lofty platform with London at their feet, serve as *repoussoir*, taking the viewer's eye and leading it into the picture. The map itself (again combining three dimensions with flat mapping) shows the City tidily compressed within its walls, connected by the Strand, with its flanking grand houses, to Westminster, clustering round the Abbey, and the Palace of Whitehall. The only developments on the south bank are Southwark, at the bridgehead, and very solitary away to the east, Lambeth Palace, the residence of the Archbishops of Canterbury. The total effect of the map, with the dense, complex mesh of the city pinned by the spectacular spire (a mile or so high as

23

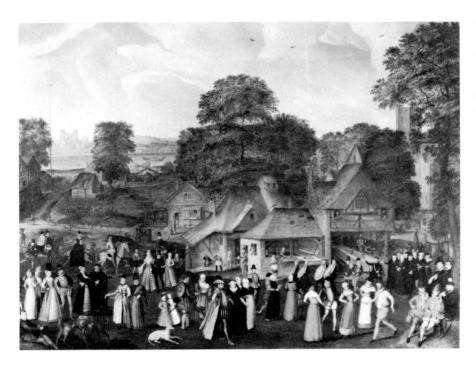

Joris Hoefnagel, *Fête in Bermondsey, c.* 1571. A crowded, outdoor scene set on the south bank of the Thames, with, on the left, a view towards the river, the Tower and Wapping. It is not certain which church is represented on the right, but St Mary Magdalene, Bermondsey, is a possibility.

shown) plumb central, and set in the larger chequered patterning of the variegated fields of the countryside, is like that of a splendid patchwork quilt, and so positively cosy – which Elizabethan London surely was not.

Close-ups into the life of the city, the street view as distinct from the panorama, are very rare indeed. In a painting of the 1590s, an exceedingly melancholic young man, eyes cast heavenwards, broods under his high hat with the Tower lowering beyond (p. 23). There is a unique glimpse of the Tower as background to happier circumstances in a *Fête in Bermondsey* painted by Joris Hoefnagel probably when he was in England in 1571 working for Braun and Hogenberg. Though Bermondsey was still a village then, there is a view opening up through the trees on the left to the Thames with the Tower prominent on the far bank. The actual site has still to be identified with any certainty, as also has the exact nature of the festivity in the foreground: conceivably it is essentially a depiction of Elizabethan Londoners, costume studies almost, showing all classes dressed in their festive best, though the approach of the party in sombre black from the church points to some specific occasion, while some of the figures are drawn with an individuality that suggests they must be portraits. The whole scene conveys vividly how intimately London was bound to its rural setting.

THE SEVENTEENTH CENTURY

THE PROLIFERATION OF BOOKS OF MAPS and panoramic portraits of cities from the 1570s onwards provides ample evidence of the popular demand for them. The most accomplished of the early long views was Visscher's engraving of 1616, taking up the theme first stated in Wyngaerde's drawings: London seen from a high viewpoint, looking north across the river (pp. 26–7). St Paul's is dominant on the skyline, now spireless but huge, its lost spire amply compensated for by the volleys of steeples and towers thrusting from the city eastwards to the cupolas of the Tower. A city born in splendour on the breast of the teeming Thames, with winged angels in the sky above blasting her fame on trumpets bannered with her heraldry. London Bridge, as always in such views, is given great prominence, taking the eye deep into the picture on its long slant. For Londoners the bridge was one of the wonders of the world. Twenty years before Visscher, the Englishman John Norden (one of the very rare natives of any ability to salute his city) published *A View of London Bridge from East to West*, dedicated to the Lord Mayor:

> Among manie Famous monumentes wtin this realm none Deserveth more to be sett before the Worlds view by demonstration then this londen bridge. And yet it hath not found so much Grace amonge the more sufficient artists. And therefore I the menest Being therunto moved Have under yor garde adventured to Publish this rude Conterfeite thereof to the end that as by reporte the fame of it is spred through manie nations So by this picture It may appeare to such as have heard of it and not reallye Beheld it to be no lesse prays worthy then it hath bene sayde to bee . . .

Norden published this in 1597, and again ('the Plate having been neare these 20 years imbezzled and detained by a Person . . .') in about 1624, by which time the Netherlandish immigrant artists, who had supplied the best in most spheres of English art since the Renaissance, were focusing more attention on the landscape. Landscape painting was not then a prestigious art compared with history painting or portraiture, but its utility, even for practising by polite cultured persons, was being recommended by Henry Peacham in his *Compleat Gentleman* of 1622, for it 'bringeth home with us from the farthest part of the world in our bosomes, whatsoever is rare and worthy the observance, as the generall Mappe of the Country, the Rivers, harbours, havens, promontories,

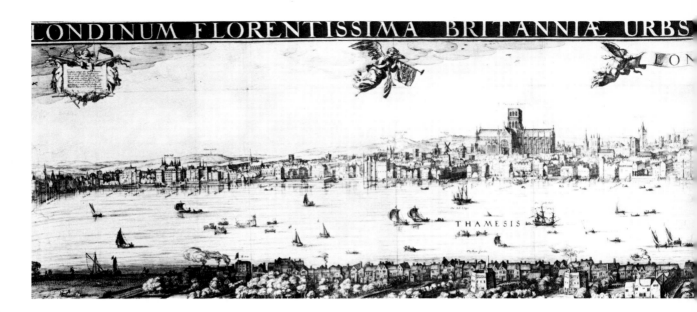

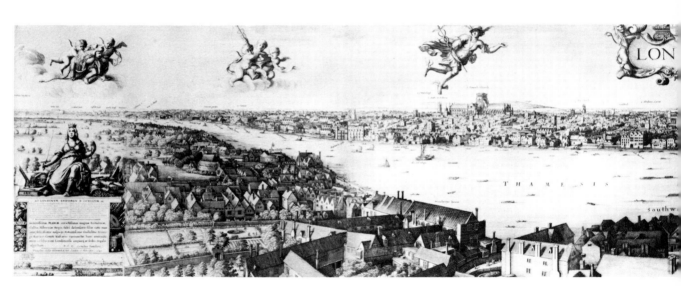

TOP **C.J. Visscher**, *Long View of London*, 1616. The most accomplished and exact of the early seventeenth-century engraved long views of London, though based in part on an earlier view by John Norden.

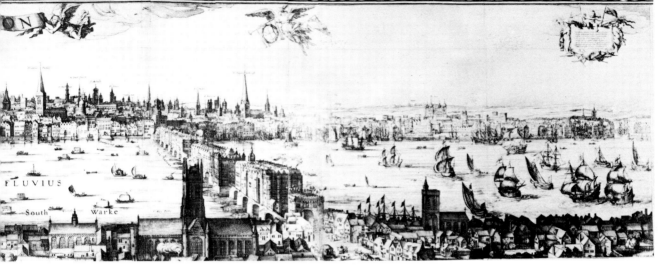

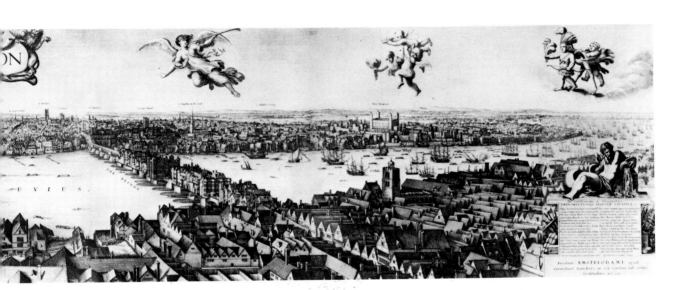

ABOVE **Wenceslaus Hollar**, *Long View of London*, 1647.
Hollar's view is taken from almost the same point as
Visscher's (conceivably from the tower of St Mary's
Overy which does not appear in the Hollar print), but
London is shown from a different angle.

etc. within the Landscap, of faire hils, fruitfull vallies' The art of landscape could perform the recording function that is now met by the camera, but could also feed sweet memories. It was to be a century before English professionals of quality were to focus on London as a subject, but while the immigrants and passing visitors who were moved, or commissioned, to depict the city were not of major stature (with one exception), the level of competence could be high. If unfortunately neither of the two greatest painters attracted by Charles I to his court, Van Dyck and Rubens, dwelled on the beauties of the city in which they were guests (with the exception of a vague suggestion of some London features in the latter's vision of Charles as St George), some of the lesser talents did. 'Lesser' is unduly denigrating: the painting of London Bridge by Claude de Jongh, a visitor from Utrecht in the 1620s, is an astonishing and undervalued masterpiece (pp. 36–7). Decked with the fantastic finery of its houses, the bridge stands in its reflection in the tranquil water of low tide, as dream-like as any fairy-tale castle, yet solid in unwavering light as if of now. Its conviction of reality is formidable, yet it is not very subservient to known fact in detail: it has for example round arches rather than the pointed ones that were really there. It was based on drawings made in 1627 on site, but was painted in and dated 1630, probably after the artist's return to Holland, presumably for a Dutch client. Another obscure but most competent artist was the monogrammist VM, perhaps Flemish, who in 1637 painted one of the promoters of the New River

'**VM**', *Sir John Backhouse* (detail), 1637. Backhouse was one of the original directors of the New River Company set up by Sir Hugh Myddelton to supply fresh water to London's citizens, especially to those living in the northern suburbs, by building a new river and reservoir. The detail shows Backhouse's hand resting on a painting of the new River Head and the waterhouse which was situated in Clerkenwell.

Wenceslaus Hollar, *The East Side of Southwark towards Greenwich.* A preliminary study for Hollar's *Long View of London* published in 1647.

Head project (a huge improvement to London's water supply), Sir John Backhouse, showing him with one hand resting on a delightful little landscape of the River Head with a prospect of St Paul's and the City beyond.

Wenceslaus Hollar, the first artist whose name is indelibly linked with London and the main agent through whose eyes we can visualize the London of the Stuart kings, was also a foreigner. Though not a Netherlander – he was born in Prague – he had been trained in the North European topographical tradition with the German publishers Merian and Hogenberg. His talents were recognized by the first of the great English *virtuosi* and collectors, the Earl of Arundel, travelling in Cologne in 1636. Hollar came to England in Arundel's service, and stayed for most of his life till his death in 1677, though latterly dependent no longer on aristocratic patronage but on the tougher terms of booksellers. He died in poverty, suggesting mildly to the bailiffs that they might let him die before they removed his bed, but left behind a copious record of the life of his time, especially of London.

Hollar was a dedicated, ceaseless worker, with a quiet but sensitive style. His drawings, sometimes enhanced by a delicate wash of colour, served as a basis for his etchings, and the medium of etching, as distinct from the laborious cutting into the copper-plate necessary in engraving, allowed him to carry over the freshness, vitality and sensitivity of his drawing into the print. Hollar's London is conditioned in part by the nature of this medium – grey or silver under a muted sky, with shadows lightly marked if at all. Some of his most engaging views occur as glimpses in the background of other subjects, notably in the splendid series of *The Four Seasons*: the marvellous masked lady in *Winter* (p. 30) has all the hurly-burly of Cornhill going on behind her – busy pedestrians, waggon traffic, and even, rising from the chimneys in the still air, plumes of smoke, a rarity in London views at that date.

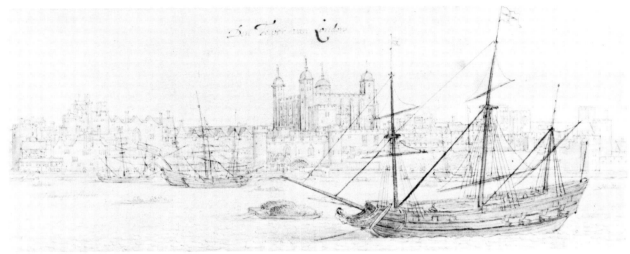

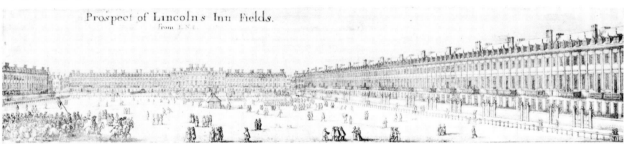

Prospect of Lincolns Inn Fields.
from E.N.E.

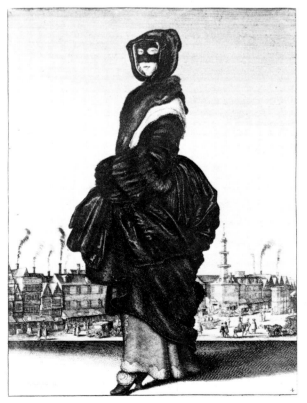

TOP **Wenceslaus Hollar**, *The Tower of London*. At the time of this drawing, the Tower was not only a fortress, prison and armoury, but was also the repository of the Crown Jewels and the State Archives, and contained the Mint and the Royal Menagerie too.

ABOVE **Wenceslaus Hollar**, *Lincoln's Inn Fields*. At the beginning of the seventeenth century there were real fields to the west of Lincoln's Inn. As the century progressed the site was developed, and the 'Fields' were lined with spacious and elegant houses, many of which have now disappeared.

LEFT **Wenceslaus Hollar**, *Winter* from *The Four Seasons*, 1643. In the background is Cornhill and the tower of the Royal Exchange. The small building on the extreme right was known as the Tun: built in 1283, it was a jail for rowdy citizens.

OPPOSITE **Wenceslaus Hollar**, *Gray's Inn to the River* from *West Central London*, *c.* 1658. An incomplete sheet from an intended large-scale map of London which has street lines in plan but buildings and other features in isometric projection. Most of the houses shown had been newly built or much altered during a building boom in this fashionable district of London during the first half of the seventeenth century.

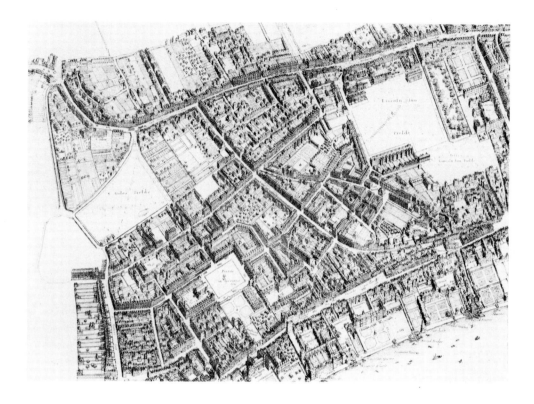

Hollar knew London and published comparative views of the city before and after the Great Fire of 1666. Two of his most remarkable achievements came before. First was the most vivid and convincing of all the long view prints of London, seen from the south bank (pp. 26–7). The viewpoint is close to that of Visscher and others. The roof-tops and gardens of the suburb of Southwark in the foreground are accounted for in doting detail; minute figures perambulate, a flag flies over the Globe Theatre. Hollar achieves an unusual strength of light and shade, and a vivid impression of a great city in the sunshine of a summery afternoon (heedless of Mercury and other allegorical figures disporting in the air above), albeit all in black and white. The main movement in the detail of the composition is, as in Visscher, in the angles of gables and roof-tops. In the foreground especially, the roofscape could almost be that of a more outlying prosperous suburb in the first half of the twentieth century (Wimbledon perhaps), and a preliminary pen-and-ink study of roof-tops (p. 29) that has survived could well be of this century, almost a Paul Klee. The impression he gives of London as a whole is subtly less rooted in the Middle Ages than that given by Visscher thirty years earlier. Yet London as a whole was moving only slowly towards a greater urbanity of architecture, a more classical decorum,

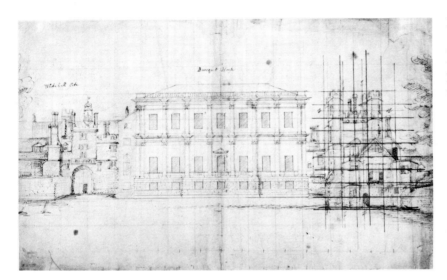

Inigo Jones, *The Banqueting House*, 1623. Inigo Jones made this drawing of his own Banqueting House for the masque, *Time Vindicated*, by Ben Jonson, which was performed there on 19 January 1623.

which indeed it was never to realize to any great extent, unlike Paris.

Inigo Jones had already staked a claim to the benefits that a rebuilding (no doubt ideally in his mind of the whole of London) in Classical-Palladian terms could bestow on the capital. His Banqueting House in Whitehall could certainly have served as module for the construction of a completely new palace, to incorporate it as one element and to replace the higgledy-piggledy of the complex surviving from the sixteenth century. A drawing by Inigo Jones of the Banqueting House in the context of its surroundings in Palace Yard speaks vividly of the indiscipline of the old and the decorum of proportion, the austere but beautifully articulated detail, the restraint of the new idioms with which it should be superseded. Also the monumental scale: to the passer-by in Whitehall now the Banqueting House may seem almost miniature, but in all views in which it appears until late in the eighteenth century it bulks enormous on the skyline above the roof-tops, together with the Abbey (still without its towers) one of the dominant features of Westminster.

As the seventeenth century wore on conscious planning, especially in the new development booming west of the City walls, began to impose here and there regularity and symmetry. This change is very vividly visible in another of Hollar's *tours de force* – an incomplete sheet towards a proposed large scale map of London drawn about 1658 (p. 31). This shows the area between Gray's Inn and the river, with the streets in plan but with all else minutely detailed in sharp isometric projection: round Lincoln's Inn the development is orderly, and the novel Piazza at Covent Garden foretells the spread of London's characteristic squares. The whole impression is of a seemly urbanity, though this may be due

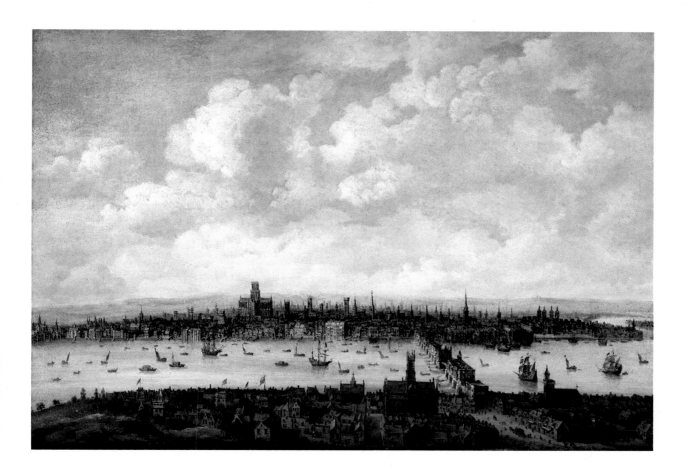

Thomas Wyck, *London before the Fire, c.* 1663. Thomas, and his son Jan, were among the large colony of immigrant Dutch artists working in London in the seventeenth century. Thomas came to England after the Stuart Restoration; works attributed to him include views of London before and after the Great Fire. He finally returned to Holland where he died in 1677.

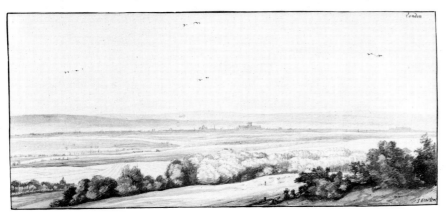

Jacob Esselens, *Distant View of London*, c. 1650–60. A spacious view of London, taken from around Haverstock Hill, showing the city sunk into the Thames valley, almost hidden by the surrounding countryside.

in part to the greatly increased angle of view and a smaller scale than in the foreground of Hollar's long city view. Hollar, and other engravers after the Restoration, produced prints of portraits of the great London houses, some of them virtual palaces in miniature, that courtiers were building mainly in the rapidly expanding West End, like Lord Clarendon's and Lord Burlington's mansions, both on Piccadilly; also views of institutions such as the new Royal Exchange built after the Great Fire in the City, and the Monument on Fish Hill that was set up to mark the starting point of the fire (p. 42).

It was by prints such as these that images of London were broadcast not only in England but in Europe, and the appetite for topographical prints, notably in Holland, seems to have been insatiable. Immigrant painters from the Netherlands however were finding a responsive market in England for local views well before the end of the century. Their names are mostly unknown now to all except specialists: Cornelius Bol, working for Evelyn in the 1660s; Danckerts, whom Pepys patronized; the versatile Abraham Hondius, Jan Griffier, Thomas Wyck and his son, the prolific Jan Wyck, though he is best known for his battle-pieces. In general, they transposed the English and London scene into a very Low Countries key, at best with charming results. In the midst of the forty-six volumes of the Van der Hem Atlas (in the National Library in Vienna) are topographical drawings of English subjects commissioned by the rich Dutch merchant who compiled this vast assemblage of views from all over Europe. They include a few of London by Jacob Esselens from Amsterdam who was in England in the mid 1650s or the mid 1660s, perhaps both. They are charming drawings in pen and ink with a light wash, highly competent and fresh exercises in the idioms of Ruysdael or Philip Koninck. A distant view of London looks across miles of clear countryside (though drawn only from somewhere around the Haverstock Hill area) to a London almost sunk from

sight in the Thames valley: in the centre, hull down like a distant battleship, St Paul's; miles away to the right, the Abbey. That is about all of London that shows, the rest is the winding countryside, the far profile of the Surrey hills, and the birds in the sky above. In other views, once in London, Esselens succumbed to the attractions of the Thames, and in the Westminster region interprets the scene in terms of a majestic recession under a huge, bird-starred sky with all the sense of space, of the movement of air through and above the low horizon that one finds in the great landscapes of Holland by his compatriots like Ruysdael. A comparably spacious oil-painting of the City from Southwark, spires straining up to a sky beset with clouds as splendid as galleons in full sail, is attributed to Thomas Wyck (p. 33).

Artists were also attracted by local dramas when sufficiently spectacular. Abraham Hondius painted two great freezes of the Thames, in 1676–7 and 1683–4 – a subject which provoked popular broadsides and prints too. Hondius's first view (p. 40) is one of the most impressive renderings of fearful cold under a livid ominous sky that I know, London Bridge forming a gaunt background, very different (though also inaccurate in detail) from de Jongh's view of it steeped in light. The great draw however was, inevitably, the Great Fire of 1666. Pictures of conflagrations were popular in Europe, and many prints were produced, in Holland as well as England. Several artists painted the London fire, including Jan, or more probably his father Thomas, Wyck. Existing prints of long views had flames added to them. The most impressive surviving painting is by an as yet unidentified artist, seen as if from a boat below the Tower, looking upstream beyond the bridge to the lurid heart of the fire with Old St Paul's an incandescent spectre central in it (p. 40). The sense of drama, heightened by the huddle of refugees and carts in the gloom in the foreground, is superb; it is a painting which I think Turner, had he known it, would have found impressive.

Hollar etched a tumultuous and sinister plate of the execution of the Earl of Strafford; the Civil War of the 1640s is not reflected in surviving images of London, but the execution of Charles I was marked by a number of indifferent prints. A few images of other events – Titus Oates in the pillory, for example – survive, and a few of more everyday happenings. The happiest of these is perhaps a painting of Horse Guards Parade in about 1680, with the Holbein Gate and the Banqueting House in the background; in the foreground Charles II, tall as he was in the midst of his entourage, advancing into St James's Park on his favourite constitutional (p. 41). Also in the foreground are scampering dogs, some deer, and a cow looking slightly apprehensive. A cow in St James's Park seems to have become an institution, a perambulant milk-bar,

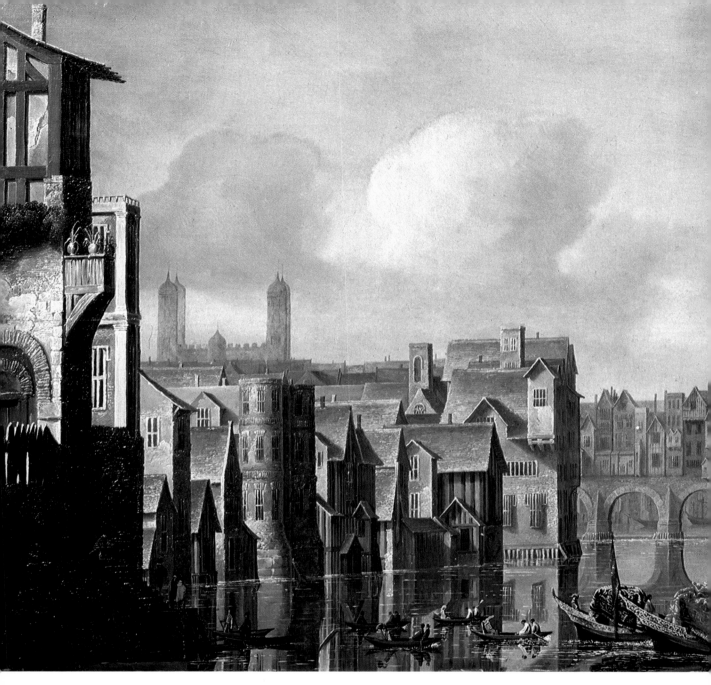
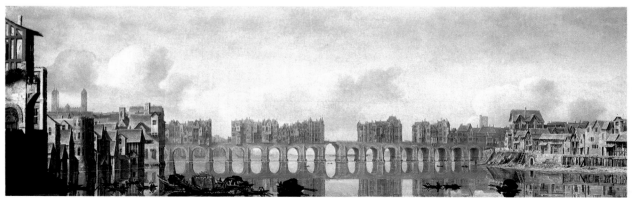

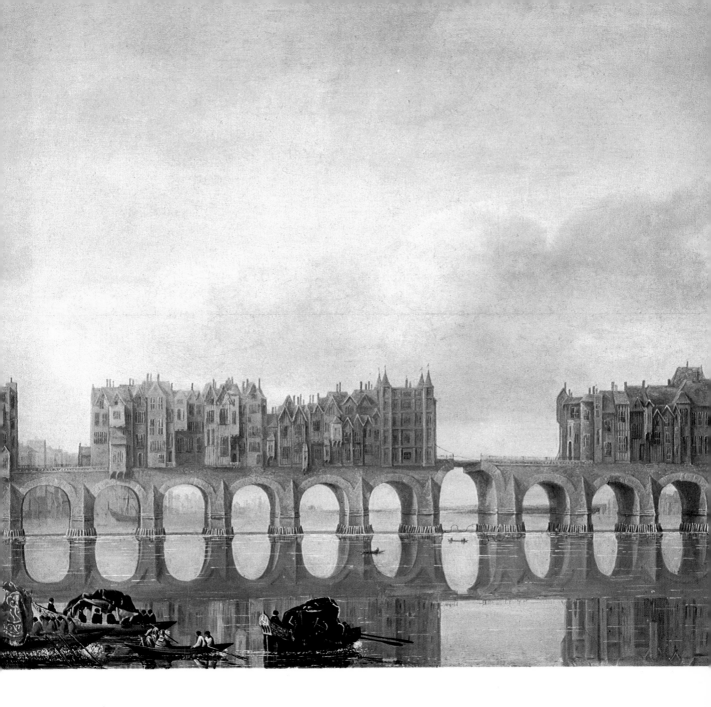

LEFT AND ABOVE **Claude de Jongh**, *Old London Bridge*, 1630. De Jongh, a visitor to London from Utrecht in the 1620s, painted this picture after his return to Holland. Although the painting reveals astonishing attention to detail, there are in fact some mistakes – the arches, for example, are all shown round-headed and the same size, while in reality they were pointed and of varying sizes – mistakes which a Dutch patron would probably not have noticed.

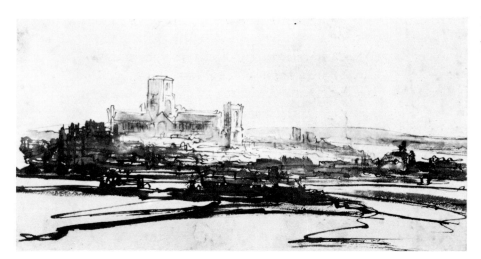

Rembrandt van Rijn, *London from the Northwest*, 1640. One of four known drawings by Rembrandt of London views, possibly the result of a visit to the city, though such an excursion has never been proved.

and by 1700 'A can of milk, Ladies! A can of red cow's milk, Sir!', was one of the cries of the park and of London. The artist of this view is as yet unidentified. In the clarity of weather and the precision of architecture, in the sprightly shorthand with which its figures are dashed in, the painting anticipates Canaletto's vision of the London scene.

Earlier in the seventeenth century there is an association of London with one of the greatest artists who ever lived – for some, indeed, the greatest. Scholarly opinion as to whether or not Rembrandt actually visited London is far from entirely solid: a story was reported in London in 1713 that he had been, not in London, but in Hull, for over a year in 1661–2. Unexpected, though not impossible, and there is no real evidence. What is indubitable is that there are four drawings – two of them with Rembrandt's signature and the date 1640 – representing St Alban's, Windsor Castle, and two views of Old St Paul's seen across the fields from the north. The last two are, in fact, a close-up of the view that Esselens took a little later from much nearer in (somewhere around Clerkenwell, not far from the church of St James there), and so including only the cathedral with the tower of St Sepulchre's in front to the right. St Paul's floats in light, set off against a foreground which is a superb example of Rembrandt's bravura with a bistre wash. Doubters argue that Rembrandt may have based his drawings on some other artist's work, prints perhaps, but none is known anywhere close enough to these drawings to justify an assumption that Rembrandt could have extrapolated his images from them. Alternatively, it has been suggested that they are the work of a pupil who had visited England – Rembrandt did indeed sometimes sign a drawing by a pupil which perhaps he himself had also touched – but the quality, especially of the Windsor drawing

and that of St Paul's in the Berlin State Museum, is such that I am tempted to claim that if they are not from Rembrandt's own hand, I'm a Dutchman. Extrapolations they are of course, but, as was Rembrandt's wont, from nature itself. He was not an artist interested in topographical literalness (for instance, the characteristic pinnacles of St Sepulchre's are blunted almost to extinction in the Berlin version), but in the drama of light and shade in space. He was, in contrast, much more concerned with the topography of human faces, and a visit to London in 1640 raises the tantalizing possibility that Rembrandt could have painted Charles I, and perhaps established a counter-image of the Martyr King to offset that with which Van Dyck monopolized the attention of posterity.

In the second half of the seventeenth century there were not one but two fires. The first, of 1666, burned the heart out of the City in the terrible three-day-long fire-storm documented so vividly by Pepys. The second, less spectacular and unnoticed by the artists, came in Westminster on a January night in 1698, sparked from drying linen left too close to the charcoal embers, and utterly destroyed the Palace of Whitehall – the heart of royal Westminster. Both catastrophes offered opportunities for a new London to spring from the ashes in a form more suitable for the age of reason and enlightenment now dawning. In the City, before indeed the ashes were cold, plans were being thrust upon Charles II by John Evelyn, Robert Hooke and Christopher Wren. These suggested different versions of a rational grid plan, centring on a new St Paul's, allowing a decorum, an opening up of grand vistas, as becoming to a great metropolis, a setting for the ceremonial of civic, rural and national pride.

None of the plans was realized: the stranglehold of vested interests in property ensured that in essence the old, indeed medieval, pattern in the City of streets, lanes and alleys was perpetuated. Similarly at Whitehall. Whitehall had never been an entity, fitting for majesty ('ill-built', noted a foreign visitor in 1665, 'and nothing but a heap of houses, erected at divers times, and of different models'). Inigo Jones's son-in-law, John Webb, had produced grandiose designs for a coherent palace before it was burnt; Christopher Wren produced more, to include Jones's Banqueting House, the only important element in the palace complex to escape the fire. Again nothing was realized, perhaps because the emphasis in Whitehall had shifted from the Crown to Parliament, and Westminster Hall and St Stephen's where Parliament sat were becoming ever more the true seat of power. So William III (if partly for his asthma) moved to the upper slopes of Kensington, and when in the West End, the court used St James's. Nevertheless if London in its centre was tenacious of the old plan, it was expanding in the West End in the comely growth of aristocratic squares, and in the City most spectacularly in the delightful dance

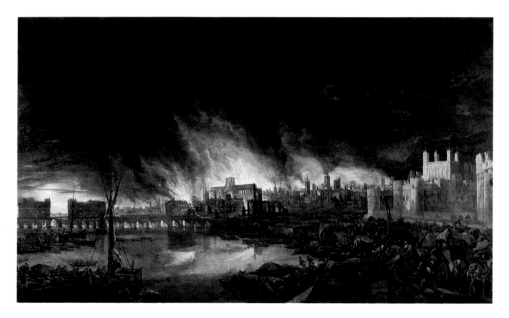

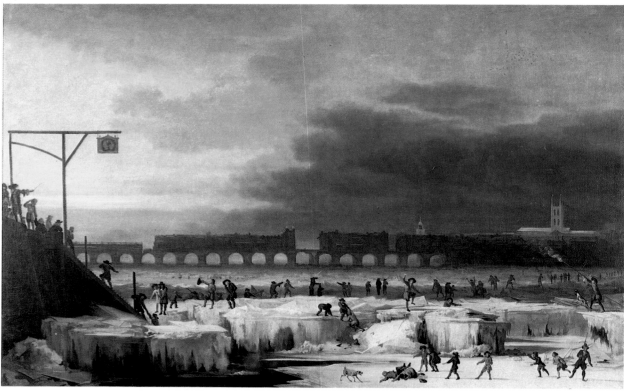

TOP **Unknown Artist**, *The Great Fire of London, c.* 1666. London is seen as it appeared between 8 and 9 o'clock on the evening of 4 September when the flames began to reach Old St Paul's but before the roof had collapsed.

ABOVE **Abraham Hondius**, *The Frozen Thames, Looking Eastwards towards Old London Bridge,* 1677. The waters of the unembanked Thames moved more sluggishly than today and tended to freeze up in a hard winter.

RIGHT **Unknown Artist**, *Charles II on Horse Guards Parade* (detail), *c.* 1680. Behind King Charles, surrounded by courtiers, the Banqueting House and the towers of the Holbein Gate can be seen.

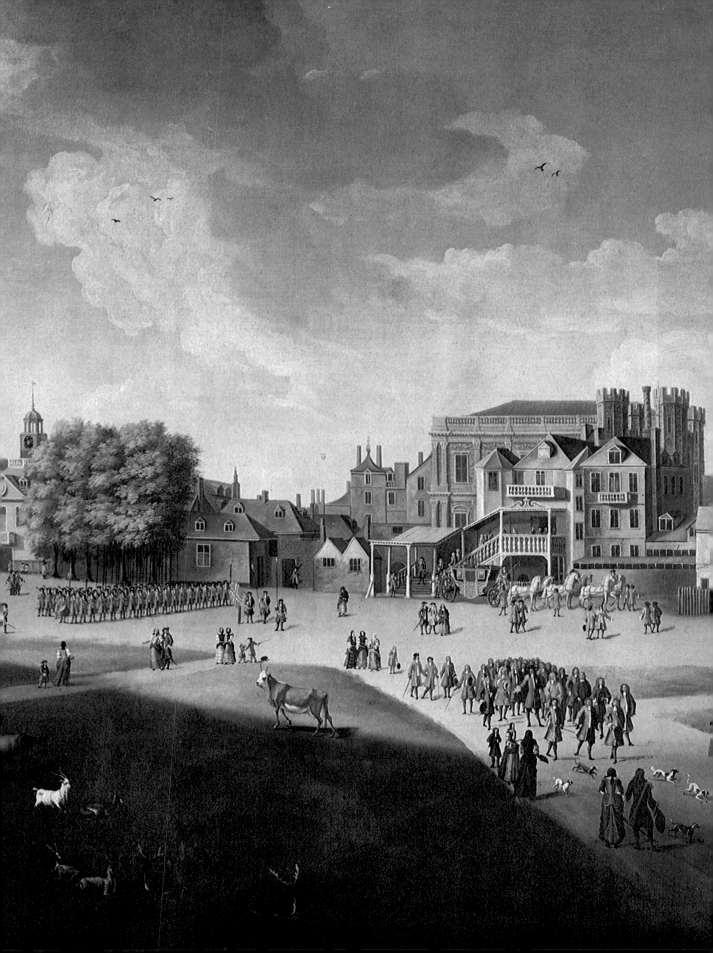

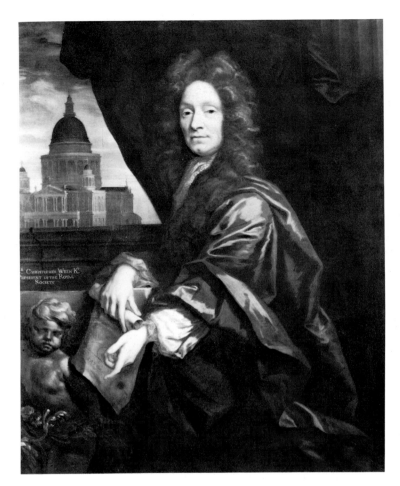

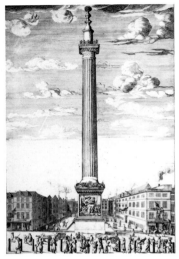

ABOVE *The Monument, c.* 1676. The Monument was erected in 1671–7 to commemorate the Great Fire. Designed by Wren with the help of his friend Robert Hooke, it consists of a fluted Doric column in Portland stone, 202 feet high, surmounted by a vase of flames.

LEFT **J.B.Closterman**, *Sir Christopher Wren*, mid-1690s. In the corner of the portrait is a picture of St Paul's according to an intermediate design. Work was begun on the new cathedral in 1675 and was not completed until some thirty-five years later.

of spires with which Wren sparkled the air about St Paul's. The most moving image of that process is the superbly elegant portrait of Wren himself by J.B. Closterman (chosen portraitist also of the philosopher 3rd Earl of Shaftesbury, whose neo-classic and rationalist writing was to have such effect on British art in the eighteenth century). It is some time in the mid-1690s. The great architect sits, the curtain behind drawn back to reveal St Paul's as if complete. It is shown, though, according to an intermediate design (with round towers on the west) that was not followed, and the plan in Wren's hand is not of the cathedral, but relates to his solution of a problem in pure mathematics – the rectification of the cycloid. Wren is presented as if presiding over the future of London itself, a future in which, while plans would consistently fail to materialize quite as envisaged, his cathedral would indeed be dominant.

THE EIGHTEENTH CENTURY

THROUGH THE EIGHTEENTH CENTURY British-born artists at last began to scrutinize, to record and to celebrate their capital city, even though the man whose vision of London in mid-century has captivated posterity was again a foreign visitor – Canaletto from Venice. Before we come to him, however, we must glance at a figure who, besides being the first English artist to establish a major reputation in European terms, was famously a quintessential Londoner, indeed a Cockney born within the sound of Bow Bells: William Hogarth.

No one would claim that Hogarth was a topographer: he was no literal translator, no antiquarian, nor generally did he respond to the visual poetry of townscape. He had, though, a remarkable power of evoking universal and timeless values via the most minutely detailed characteristics, eccentricities even, of the people with whom he peopled his moral visual comedies – the 'Progresses'. So too he gave immediacy to the scenes of his dramas by siting them in settings which would have conveyed immediately to contemporaries the feeling that the action was going on in London, and so strengthening the credibility of his fictional story. A great deal of Hogarth's action is in interiors, and the metropolitan feel of these is no longer as discernible as it must once have been, nor is it clear how faithfully they reflect actual interiors, whether say of a rich merchant's home or of the horrors of the tavern scene in *The Rake's Progress* or of Bridewell or Bedlam. (In fact the tavern is generally identified with the notorious Rose Tavern in Drury Lane.) One critic has even observed a parallel between 'the moral and physical ideas of the progress' toward salvation or perdition, a progress illuminated geographically by its stages through the different quarters of London, especially between the City of the merchants, and the new developments – the West End of fashion. So in the last scene of *Marriage à la Mode*, in the house of the bride's merchant father, Old London Bridge is seen through the open window, its ramshackle houses teetering on the brink of collapse into the river (p. 45); in an earlier scene, an exquisitely bored husband and wife are in a grand reception room in the style of the West End. In *A Harlot's Progress*, the harlot, on arrival in London, is greeted at the Bell Inn in the City. In *The Rake's Progress*, the hero's initial downfall is sited very precisely: his arrest – heaved from his sedan chair while arriving for a fashionable reception – takes place at the top of St James's Street, with the Gatehouse of St James's

LEFT **William Hogarth**, *The Times of Day: Morning*, *c.* 1736. On the left is part of the portico of Inigo Jones's church of St Paul's, Covent Garden, with its flanking gateway and houses. Tom King's coffee house is wrongly placed in front of the church.

ABOVE **William Hogarth**, *Marriage à la Mode: The Suicide of the Countess* (detail), 1743. The scene of the last episode in the series is the home in the City of the Countess's father, whither she has returned after the death of her husband. The coat-of-arms of the City is set in the stained-glass of the window, through which Old London Bridge can be seen.

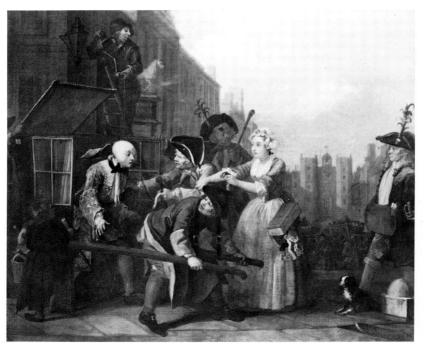

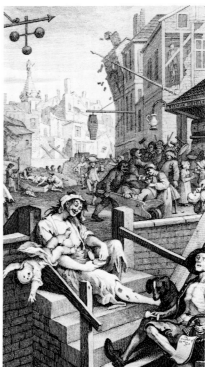

ABOVE **William Hogarth**, *The Rake's Progress: The Arrest*, 1732–4.
RIGHT **William Hogarth**, *Gin Lane* (detail), 1750–1.

Palace clearly recognizable down the hill in the background.

In such incidents however the urban setting is strictly subsidiary to the human drama. Perhaps only in the four paintings of about 1736, *The Times of Day*, and the engravings made from them, does the setting become almost as important as the action. Of the four *Evening* is the least specific, though marked as being at Sadler's Wells – then a watering place clear of the city – by the inn-sign. *Noon* has fairly indeterminate buildings, though the general location is again signalled by the spire of St Giles-in-the-Fields behind them. *Evening* contrasts the squalor of a London slum lane with the not-so-distant elegance of Le Sueur's equestrian statue of Charles I, seen beyond and so hard by Charing Cross. In the superb masterpiece of the four, *Morning* (p. 44), the whole setting is sharply portrayed both in terms of architecture and of weather, and is timed – by the clock, clearly legible in the print if not in the painting – at 6.55 a.m. The lady progresses primly towards early morning service, escorted by a small page or footman. She is one of the most vividly characterized figures in English art, said to have been inspired by reality in the person of a relative of Hogarth's (who subsequently cut him out of her will), but inspiring a more endurable reality: it is to Hogarth's lady that Henry Fielding refers the reader who wishes to know what Bridget Allworthy in *Tom Jones* looks like; likewise the poet William Cowper in *Truth* refers his reader to her as the personification of a prude. In thin

uprightness, offset by the splendour of her dress, she refuses to see the bawdy group round the fire (or, visible in the engraving, the conflict within Tom King's coffee house behind them: a wig, detached from its owner's head, is hurtling out of the door). The painting is one of the rare early views of London in deep winter: in the livid light of a murky dawn, snow on the roofs of the tall houses shines palely; icicles fret the gutter of the coffee house. The topography is fairly accurate (though in the print it is reversed), but the coffee house – notorious in its time – has been moved into a proximity with St Paul's Church which it never had. Perhaps Hogarth never consciously intended to offset the architectural proprieties of Covent Garden – paradigm, with Inigo Jones's great Classical barn of a church and the so-called 'Piazzas' or arcades, of ideal urban architecture for London no less than was Jones's Banqueting House in Whitehall – against the improprieties of lechery and near-riot of common or (Covent) garden humanity, but the contrast is very telling. Hogarth's resentment of the contemporary upholders of the Palladian, neo-classic tradition – Lord Burlington and especially his chief protégé, William Kent – was obdurate and frequently expressed, but the main impact of this image is that of glimpsing a fragment of London life in a corner of London, alive now as it was in the late 1730s.

The conviction of actuality in *Morning*, and to a rather lesser degree in the other three paintings in the set (believed to have been designed originally as decorations for boxes in the Vauxhall Pleasure Gardens), is stronger than in Hogarth's two most famous prints with specific reference to London streets: *Beer Street* and *Gin Lane*. Unlike the four paintings these two later prints, published in 1751, had deliberate moralizing purpose ('calculated to reform some reigning vices peculiar to the lower Class of People', pronounced Hogarth's advertisement for them). *Gin Lane* ('Gin cursed Fiend, with Fury fraught / Makes human Race a Prey. . . .') is set in the slum area then known as the Ruins of St Giles, in Westminster. The church steeple is indisputably that of St George's, Bloomsbury; as Dickens was to comment: 'indeed very prominent and handsome, but . . . quite passive in the picture, it coldly surveys these things in progress under its tower'. The streets are not identifiable, the whole emphasis being on the only too vivid representations of human misery. Whether *Beer Street* is much more attractive ('Beer, happy Produce of our Isle / Can sinewy Strength impart. . . .') to modern eyes is doubtful, but certainly the only character in that engraving in misery is the pawnbroker. The church steeple bears a vague resemblance to that of St Martin-in-the-Fields, but the street itself is a generalized portrait. Together the two prints offer vivid concentrations of two extremes of mood in London life.

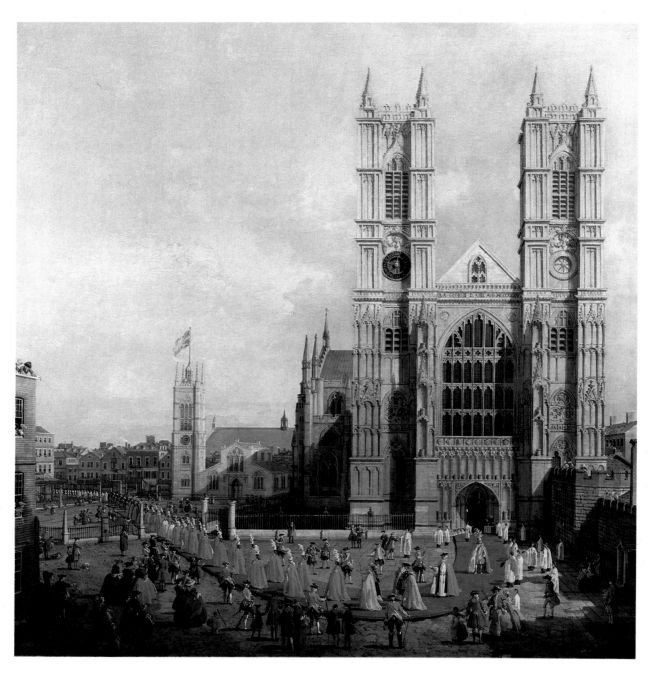

Canaletto, *Westminster Abbey, with the Procession of the Knights of the Bath*, after 1749. The procession is that following installation in Henry VII's Chapel in 1749: the knights have left the Abbey and are on their way to Westminster; bringing up the rear is the Great Master of the Order of the Bath, preceded by the Dean of Westminster. In the background is the west front of the Abbey; to the left, St Margaret's.

An entirely different aspect of London was being offered by a visitor who had already been active in the city for five years when Hogarth's prints were published. Giovanni Antonio Canal, better known as Canaletto, arrived in England from Venice in May 1746. Apart from a few months back in Venice in 1750–1 and again in 1755, he remained in England, mainly in London, until his final return to Italy probably in about 1756. His 'English period' consisted then of barely a decade. Yet, like that of another distinguished temporary immigrant in the previous century, his impact on art in England was out of all proportion to the length of his stay. Van Dyck, in ten brief years between 1631 and his death in 1641, transformed the English conception of portraiture, and his influence echoed on until Sargent, even until today. So Canaletto, even if not so overwhelmingly, established a new vision of English topography, and especially of London townscape, to which later painters were to refer back until well into the twentieth century.

He was already forty-nine years old when he arrived. His style was by then fully established and was known to, and highly esteemed by, many important English connoisseurs and collectors who, having stopped off for a time in Venice on the Grand Tour, had been bewitched by the magical spell of that most beautiful of cities afloat on her lagoon. A significant number of them brought back with them memories crystallized in permanent form on the canvases of Canaletto, as today humbler travellers return stocked with colour postcards. English travellers had come to provide an important proportion of Canaletto's patronage, and the holdings in Britain of his paintings, even leaving aside those of English subjects, are still the richest in the world. Moreover, by the time he arrived in 1746, his English patrons had been deprived of his services for some years owing to the disruption of travel on the Continent brought about by the War of the Austrian Succession. It seems fairly clear that as Canaletto's most profitable patrons could not come to him, he must go to them.

The patrons responded. An intermediary wrote to the Duke of Richmond, 'I told him the best service I thought you could do him wd. be to let him draw a view of the river from yr. dining-room which would give him as much reputation as any of his Venetian prospects. ...' The Duke civilly obliged, his reward being Canaletto obliging too with a couple of masterpieces that rank amongst the finest of his whole career: the two views from Richmond House in Whitehall – one looking over the river to St Paul's and the City, the other looking north up Whitehall over what had been the Privy Garden of the palace (pp. 50–1). They are still in the ducal family collection at Goodwood.

Both paintings are almost square, a rather unusual format in Canaletto's work, and he took advantage of these dimensions to establish constructions

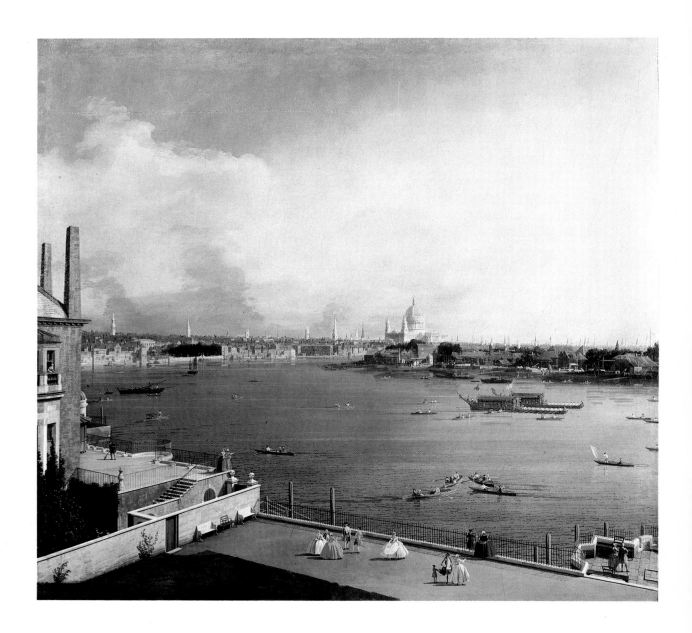

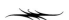

ABOVE **Canaletto**, *The Thames and the City of London from Richmond House*, 1747? In the foreground is the terrace of Richmond House and, to the left, that of Montagu House. On the left bank of the river can be seen (from left to right) Old Somerset House and the spires of (amongst others) St Mary-le-Strand, St Clement Danes, St Bride's and St Paul's Cathedral. On the right bank of the Thames are timber and stone workshops.

RIGHT **Canaletto**, *Whitehall and the Privy Garden from Richmond House* (detail), *c.* 1746–7. At the far end of the Privy Garden is the Banqueting House and, in the courtyard to the right, the bronze statue of James II by Grinling Gibbons, now in Trafalgar Square.

that have a monumental quality. The strong diagonal recession that he found so irresistible is there in both of them from right to left – most emphatically in the noble sweeps of the river from the terraces of Richmond House bearing round to where St Paul's rises as if summoned up from dream, its southern flank gleaming in the morning sun. Not only drum, dome and top-most golden ball float there, as do the two western towers, but the whole of the upper story of the cathedral – the *piano nobile* – rises clear above the roof-line, set off by the darker, shadowy tone of the curve of the south bank that lies between it and the viewer. Note too how the delicate exclamations of the spires of Wren's city churches attend the dome. I have wondered if Coleridge ever saw this painting: it is an image to match that of Xanadu, and it would be agreeable to read *Kubla Khan* alongside it, and Wordsworth's most famous sonnet on the view from Westminster Bridge.

This pellucid vision, that might seem indeed a phantom of reality, at least to the onlooker in the late twentieth century who has seen the City lumbered out of existence by the graceless tower blocks of the postwar developers, is anchored in the reality of its time by the human detail in the foreground. The elegance of costume and gesture in the morning sunlight on the terrace of Richmond House and, beyond the dividing garden wall, on that of next door Montagu House, may seem almost too refined to be true, as if the people there were on stage in light opera. In the companion painting, a view taken from another upper window in Richmond House a little further inland, the impression is less idyllic but in its way more extraordinary – almost a view of the backlands. In the foreground, the stable yard of Richmond House: a ladder leans against a brick wall casting its spare shadow; chickens glean on the cobbles. Beyond that, the flank of Montagu House, a glimpse of Grinling Gibbons's bronze statue of James II (that now stands outside the National Gallery) and, slightly left of centre, a curiously articulated hulk of building that is Inigo Jones's Banqueting House, survivor of the Whitehall fire, paradigm of a classic urban architecture but seen here most unclassically, end on, more than half obscured by a lower brick building. The huge shadowed arch formed by the chimney courses, like an airborne gate for winged horses, echoes oddly the arch in the yard of Richmond House, and again that of the Tudor brick of the so-called Holbein Gate on the left (to be demolished in 1759). Between the Holbein Gate and the Banqueting House, the eye looks deep down Whitehall right into Charing Cross, with a glimpse of Le Sueur's bronze statue of Charles I, that still stands there, on its pale plinth.

As townscape, the component parts seem oddly haphazard. In fact, Canaletto's views of Whitehall are of an area in the process of development. In

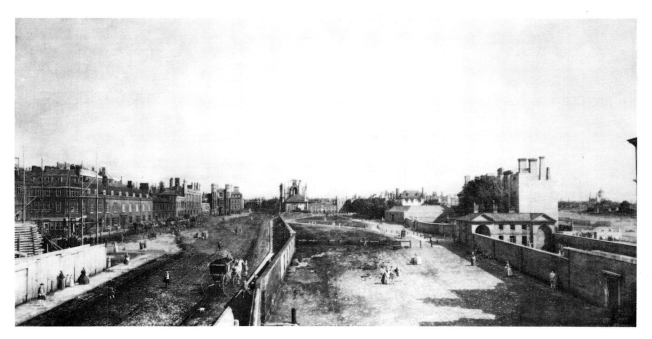

Canaletto, *Whitehall and the Privy Garden looking North*, 1751–2? Canaletto's second view of the backyards of Whitehall is taken from slightly further back. In the distance on the left is the Holbein Gate, built by Henry VIII in 1530 and demolished in 1759 to ease traffic congestion.

the second quarter of the eighteenth century an ambitious exercise was set in train to attempt to bring the fire-ravaged precinct into some ceremonial order. The key was the construction of London's second bridge, at Westminster, which was nearly completed when Canaletto arrived in 1746. There was even a grandiose scheme to sort out the jumble of houses and small streets that cluttered the Westminster end of the link between the new bridge and Charing Cross: 'propos'd to be built with a Colonade, on each Side of the Way, in the Nature of that at Covent Garden, according to a Design ... drawn by the late Mr Hawksmoor' (1738). That would have produced a majestically coherent Parliament Street, over half a mile long from New Palace Yard to beyond Charing Cross, a setting in which Inigo Jones's Banqueting House would have indeed found itself at home.

It did not of course happen. As usual in London, the grandiose town planning scheme dissolved into piecemeal development, and in 1755 an observer noted: 'I must ingenuously confess that the pretty little boxes that are built on the ruins of Whitehall make me no satisfaction for the loss of that palace.' Canaletto's first view, perhaps of 1747 rather than 1746, was followed, probably in 1751, by an even more remarkable one of the same scene but taken from a ground-floor window in the house next door belonging to the Earl of Loudon: a very unusual, even eccentric, yet magisterially compelling

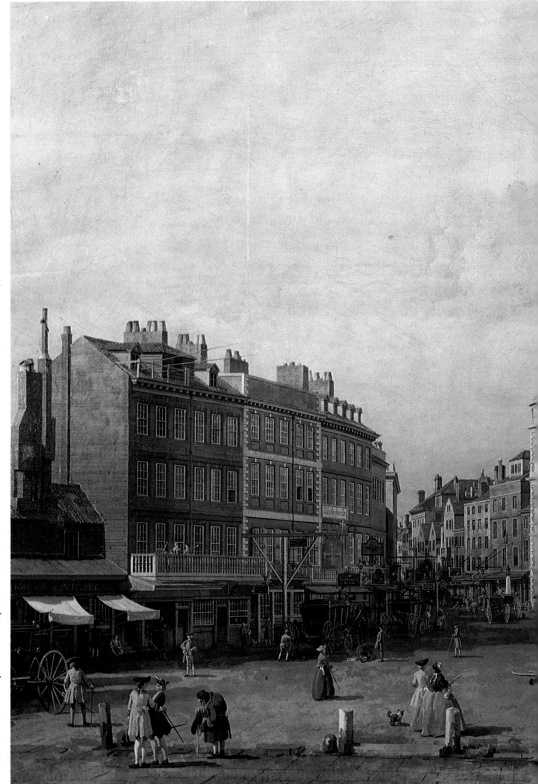

Canaletto, *Northumberland House*, 1752–3. The painting shows the façade of the house as it was reconstructed early in 1752 (Northumberland Avenue now commemorates its site). The lion surmounting the main entrance is now at Syon Park. Beyond the house is the entrance to the Strand. On the left is the Golden Cross Inn and, in the foreground, Le Sueur's statue of Charles I.

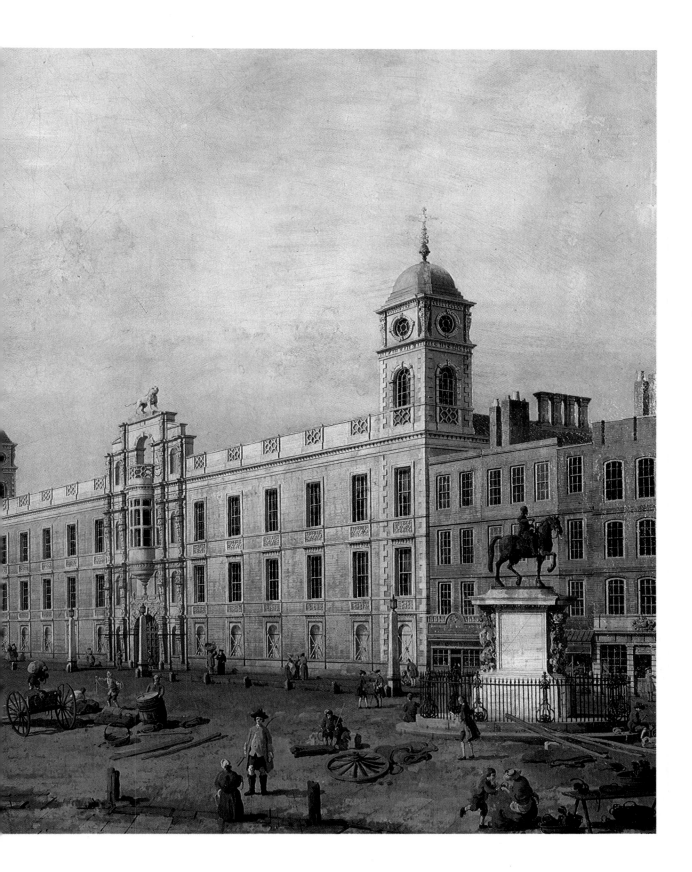

composition, split in depth by the long waver of the wall of the Privy Garden. Here development is seen in progress: scaffolding on the left tells of a demolition, while the then new-style raised pavements or side-walks are clearly shown. As a desirable subject for picture-lovers it is unexpected. It appears not to have been commissioned and was taken back to Venice by Canaletto when he finally left England. It is curious to think of the international *virtuosi* visiting Venice and contemplating this version of Whitehall in Canaletto's studio.

In London, Westminster remained Canaletto's main stamping ground. He painted the Abbey (p. 48) and Henry VII's Chapel; he painted, from St James's Park, the Old Horse Guards and then William Kent's new Horse Guards which had replaced them by 1755. He painted Charing Cross with old Northumberland House, and Charles I on his horse looking down Whitehall (pp. 54–5). He painted the brand-new Westminster Bridge, and an enchanting view up to the City seen through one of its arches (with a dangling bucket), looking down river. The dome of St Paul's and the City spires appear in his Thames panoramas, but never in close-up, and Old London Bridge hardly at all. The picturesque conglomeration of houses on the Bridge was finally cleared in 1757, the year after Canaletto probably left for good.

The quality of his English pictures was notoriously variable, even causing rumours in London that the visitor who settled in a house in Silver Street (now Beak Street), Soho, was not the genuine article but a pseudo-Canaletto. It is clear that, both in drawings and paintings, he (perhaps with assistants' aid) produced a quantity of relatively mechanical and indifferently finished repetitions, but it is by his best work that he should be judged, and the best of his English period match his earlier masterpieces in sensitivity and brilliance. Canaletto's London is of course a highly selective account. A city of leisure and of summer, basking in a climate which, one suspects, may owe something of its benign clarity to the painter's eye being conditioned by the quality of Venice. A city of fashion and elegance, whose inhabitants never exchange a cross word, but saunter and gossip and even simply stand and stare. Canaletto's insistence on the Thames developed no doubt naturally from his long acquaintance with the watery vistas of Venice, and in this subject too he may have imported a clear, clean picturesque more proper to the Grand Canal architecture of Venice than to Thames's reality. Only a few years later, a Swiss visitor recorded a different view:

> The spacious canal formed by the Thames might present us with as noble and striking an object as the great canal of Venice, lined with palaces of the most sumptuous magnificence and the most pleasing variety: but the banks

> of the Thames are occupied by tanners, dyers, and other manufacturers. . . .
> The streets where these manufactures are carried on are the dirtiest in the
> city; in fine, the bridges have no prospect of the river, except through a
> balustrade of stone. . . . All possible measures have been taken to conceal the
> prospect of this fine river, and the passages that lead to it.

The writer diagnosed that the reason for this was 'the natural bent of the
English, and in particular the people of London, to suicide', but his version is a
salutary reminder that the city Canaletto saw is also the arena in which
Hogarth was living and seeing very different things.

The actual fabric of London, building and rebuilding and expanding
remorselessly, strained towards a norm of city architecture established by
another Venetian – to the classic grammar established by Palladio. The roof-
riot of gables was a thing of the past and in the West End particularly, in squares
and streets, regular parapeted houses were becoming usual. Following various
planning (anti-fire) regulations early in the eighteenth century, façades were
modelled more interestingly, the requirement that windows be set some inches
into the brickwork producing some play of light and shade (later emphasized
when the London habit of painting the reveals white came in). A typical Queen
Anne, or earlier, house might have its windows almost flush with the surface,
producing an effect of paper cut-out models – as indeed in the tall, gabled houses
visible in Hogarth's *Morning* (p. 44) contrasted with the parapeted house
alongside. Bricks tend to London grey and brown rather than red, but stone was
always the grandest. Towards the end of the century, with the introduction of
painted stucco creating a stone effect over brick, whole areas of inner London
and the West End were to rise gleaming white or cream, though set in the ever-
expanding monotony of small-scale terrace housing in brick that turned almost
immediately into the colour of coal-smoke.

Canaletto's interpretation of London was adopted by many, and the
continual emergence in the sale-rooms even now of copies after him and of
weak variations on his theme is a constant reminder of his impact, if often a
rather depressing one. The best of the native English painters to absorb his
influence was Samuel Scott. Scott was a colleague of Hogarth, and fellow-
traveller with him on the famous five-days' peregrination of 1732, when a
group of artists went gallivanting from Covent Garden (where Scott lived) for a
few days to Sheerness and beyond. He started as a marine painter, but was
producing more purely topographical studies even before Canaletto's arrival.
He shared with Canaletto the favourite topic of London's new second bridge at
Westminster, and seems to have been recording its progress almost from the

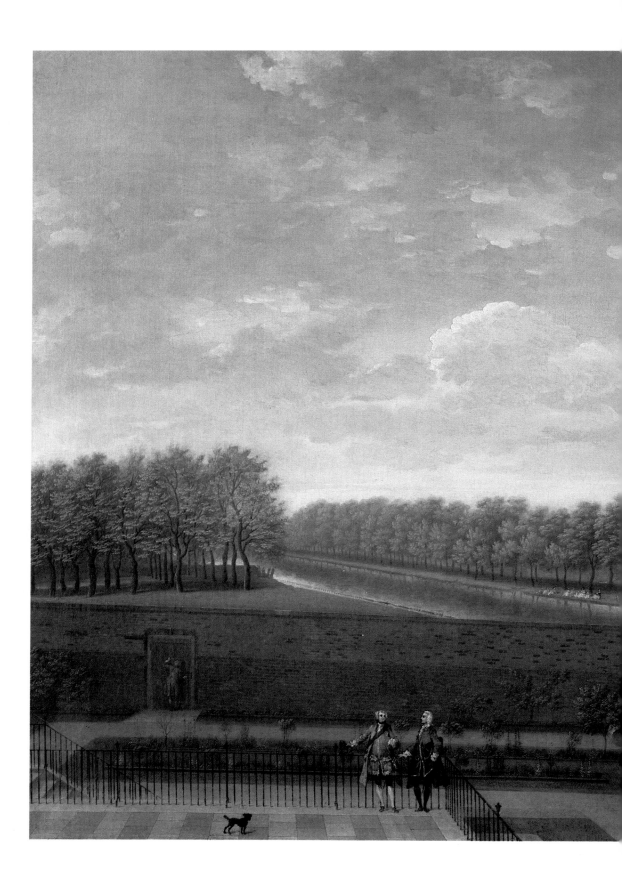

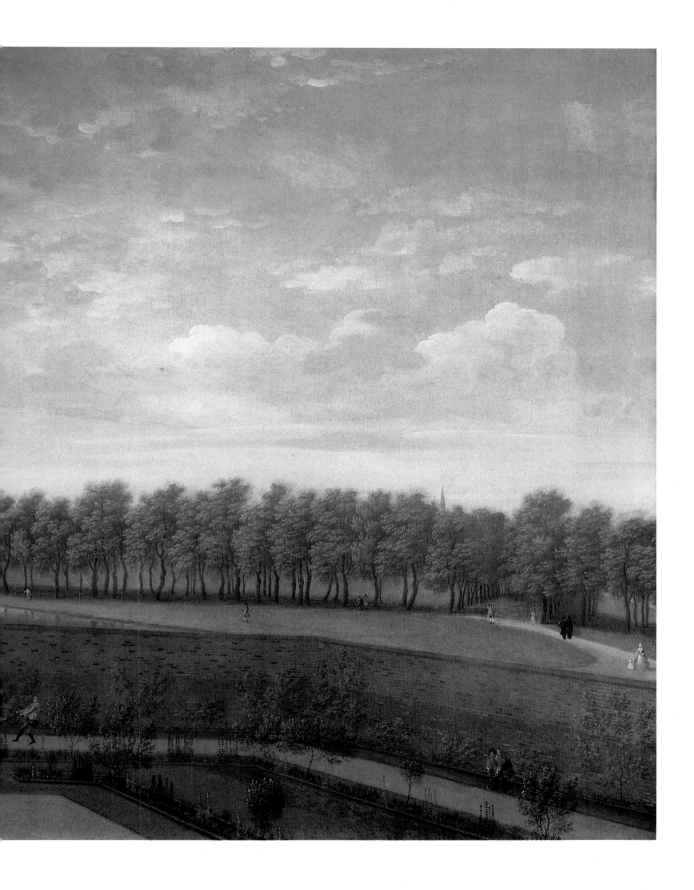

beginning, well before Canaletto. His London territory extended further to the east than Canaletto's, and it is from his canvases especially that the last of Old London Bridge is to be remembered. He painted many versions between 1746, when a Court of Inquiry considered the problem of the six-hundred-year-old, house-encumbered bridge in relation to greatly increased traffic both across and under it, and the demolition of the houses and revision of the structure that continued from 1756 on. There was a nostalgic demand for a record of one of the best-known London landmarks, and Scott's versions of it, though mostly shown under an ominously lowering sky in contrast to his sunlit views of the new Westminster Bridge (pp. 6–7), do not suggest undue decrepitude in the entrancing picturesque of the bridge's houses. A bridge with houses on it is endlessly fascinating, and it is easy even now to wish that Old London Bridge had had a preservation order clapped on it and was still thus (it would have made a splendid pair with the Victorian Tower Bridge). In Scott's affectionate accounts of it, inherent inconveniences that would be unacceptable now – lack of sanitation, for one – do not obtrude.

Scott's touch is heavier than Canaletto's, his colour less radiant, and his figures lack the operatic elegance of the Venetian's. On the other hand, just for that they may ring more true. He was perhaps at his best when his chosen composition offered a nice blend of aquatic and shipping subjects with the detail of quayside and wharf activity, and in a sense his feel of London and London life is more credible than Canaletto's. Later in his career, he had as assistant, Sawrey Gilpin (subsequently a celebrated horse painter), who appeared to have put in much of the figure work in his compositions; with Gilpin he produced one of the most satisfactory of a number of eighteenth-century celebrations of Covent Garden, shown bursting with activity. It was painted almost twenty years after Hogarth's *Morning*, but has a comparable smack of authenticity. Yet perhaps the most moving of his London evocations are found in his line-and-wash drawings of an extraordinary pale delicacy, almost ghost-like, yet establishing relationships of volume and space with the most satisfying definition. His drawing of Westminster Abbey and the river front in these terms was done as early as 1743–4, before Canaletto's arrival, and shows incidentally an addition to the then still dominant feature of Westminster, the Abbey, still in progress: one of the towers designed by Hawksmoor at the west end of the Abbey is still in scaffolding – a reminder that

PREVIOUS PAGES **George Lambert**, *St James's Park from the Terrace of No. 10 Downing Street*, 1736–40. The full relaxation of the handling of St James's Park, from the formal to the romantic picturesque, came with John Nash's remodelling of 1828.

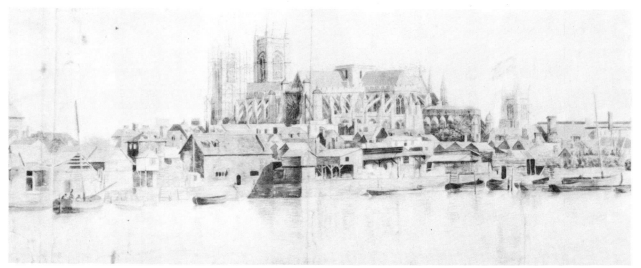

ABOVE **Samuel Scott**, *Westminster Abbey, St Margaret's and Westminster Hall* (detail), 1743–4. The two western towers of the Abbey were raised by Nicholas Hawksmoor but were not crowned by spires as he had visualized.

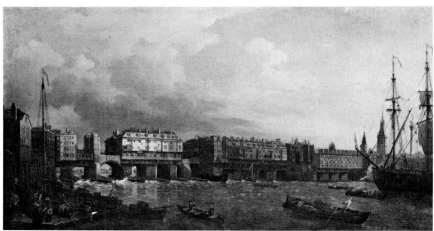

LEFT **Samuel Scott**, *Old London Bridge, c.* 1750? The east side of the bridge is shown with, on the right, the towers of St Michael, Crooked Lane, and St Magnus the Martyr; on the left, dyers are dipping a piece of cloth in the river.

RIGHT **Samuel Scott**, *Covent Garden Piazza and Market*, 1749–58. Covent Garden was laid out by Inigo Jones for the 4th Earl of Bedford in 1631 and soon became the site of a bustling market. At the west end is Inigo Jones's church of St Paul's; this burnt down in 1795 but was replaced by an exact replica which still survives. The northern blocks of Jones's houses can be seen on the right, with their stuccoed arcades popularly known as piazzas.

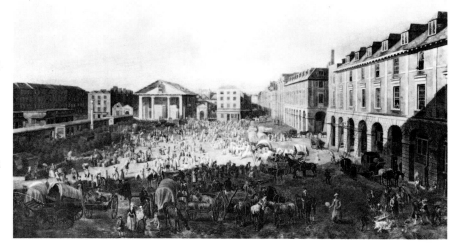

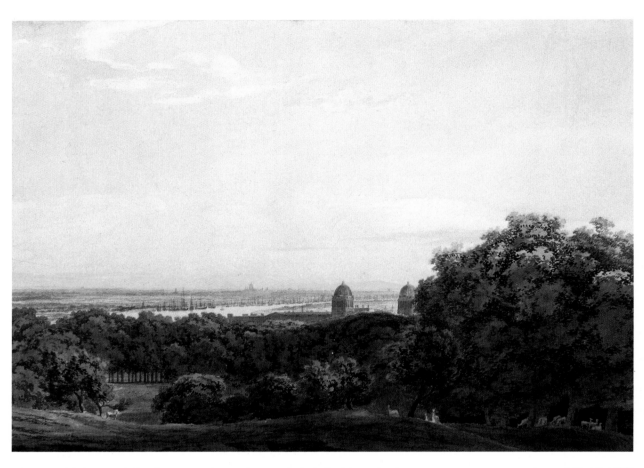

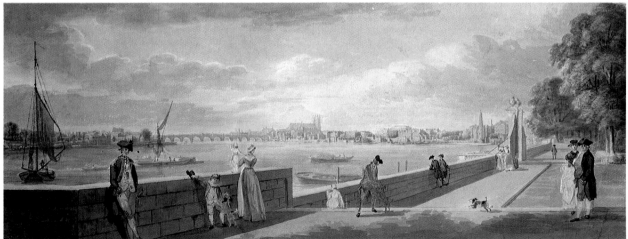

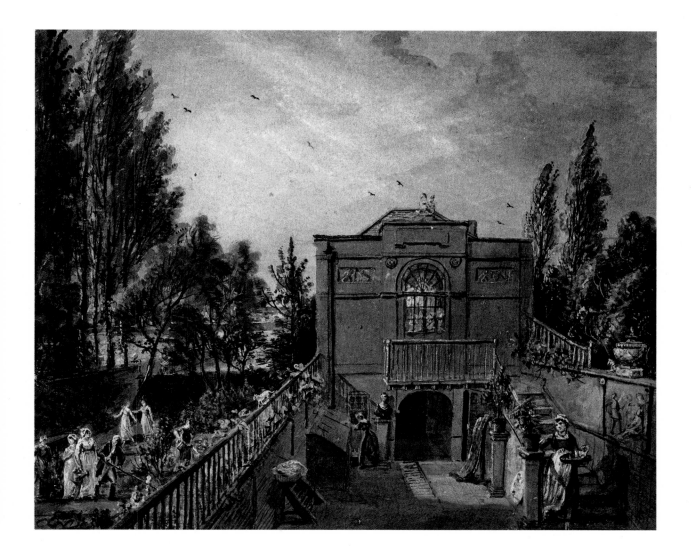

OPPOSITE BELOW **Paul Sandby**, *View towards Westminster from the Terrace of Somerset House*. Views of the Thames as it curves to display the city became a popular subject for artists in the wake of Canaletto's and Scott's vistas.

OPPOSITE ABOVE **J.R.Cozens**, *London from Greenwich Hill, c. 1791*. Greenwich Hill was a favourite viewing point of many artists for the city, seen here beyond the two Baroque domes, designed by Wren of the Royal Naval Hospital.

ABOVE **Paul Sandby**, *The Artist's Studio, 4 St George's Row, Bayswater, c. 1800*. Paul Sandby was born in Nottingham but early in his life moved to London where he worked for numerous patrons. He lived at 4 St George's Row from 1772 until his death in 1809.

the familiar silhouette dates only from 1744. Earlier than that the Abbey looms, towerless, over Westminster – most markedly in Hollar's views – often like a rather featureless, unarticulated, yet enormous hulk, a great barn or hangar. The exterior image of the great Gothic church as we know it dates indeed from later than its dominant Baroque counterpart in the City, Wren's St Paul's.

Scott was liable to play tricks with his topography, rather more so than Canaletto, though not I think to the extent of fantasy popular in Italy in the hands of Pannini and Piranesi no less than Canaletto himself. The *capriccio*, bringing together on one canvas a number of famous architectural monuments irrespective of their topographical relationship in reality, has as distant descendant the postcard featuring various views of its subject. Canaletto did some English variations on the theme – one, for example, has Charles I's statue outside the Banqueting House (with perhaps unconscious irony, as it was via the Banqueting House that Charles stepped to his execution on the scaffold). A spectacular view of the Thames seen through the arches of a Venetian *loggia* was produced by a rather obscure compatriot of Canaletto, Antonio Joli, active in London between 1744 and 1750, but the best known English *capriccio* came much later: the haunting amalgam of St Paul's and a Venetian canal scene (Tate Gallery, London), painted by Scott's most talented pupil, William Marlow, towards the end of his career, about 1795.

By mid-century, the vogue for topographical painting stimulated by Canaletto was established. It expanded often in the tradition of over-door and mantelpiece decoration that Pepys practised almost a century before. An outstanding example can be seen in the decoration of the Court Room of the Foundling Hospital where a set of small roundels, views of London hospitals, was provided by various artists in the 1740s, including not only Richard Wilson but the young Thomas Gainsborough in one of his very rare ventures ('descents', he would have claimed later) into the depiction, or portrait, of a specific place. His little sunlit idyll of the Charterhouse owes nothing to Canaletto, something to Hogarth, but most to the Dutch tradition of the urban picturesque. In its freshness and lyrical simplicity, it is one of the most touching pictures that Gainsborough was to produce, though, as we shall see, towards the end of his career he was to paint a vision of feminine loveliness afloat in city park greenery that has never been surpassed, not even by Watteau. Meanwhile however Gainsborough, earning his bread and butter in what to him was the slavery of human portraiture, refused to have any truck otherwise with literal topography. So he told a patron that if 'anything tolerable of the name of G [ainsborough]' was wanted, then 'the subject altogether, as well as the figures etc. must be of his own Brain'. He referred his prospective client elsewhere:

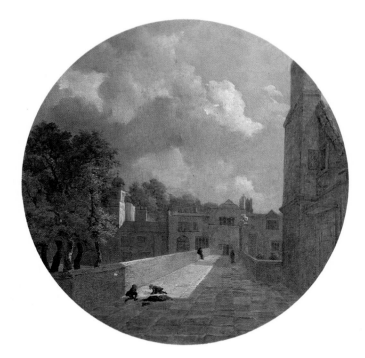

RIGHT **Thomas Gainsborough**, *The Charterhouse*, 1748. Gainsborough painted this view of the Charterhouse in Finsbury when he was only twenty-one. Founded as a Carthusian priory in 1371, the Charterhouse was converted to a hospital with a boys' school attached after the Dissolution of the Monasteries.

BELOW **Thomas Gainsborough**, *The Mall in St James's*, 1783. Ladies of fashion and beauty are portrayed promenading along a silvan walk into which Gainsborough has bewitched the Mall in St James's Park.

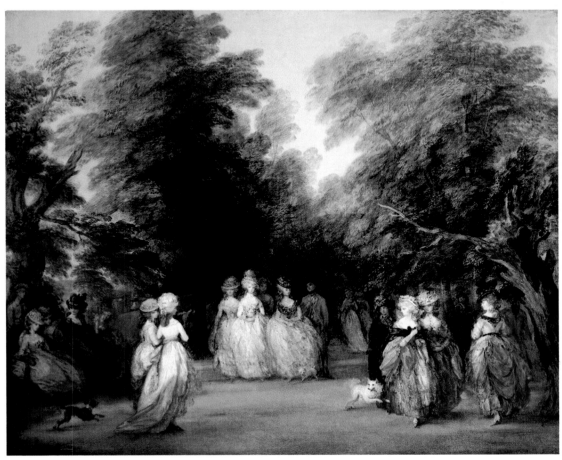

Joseph Farington, *Figures Standing on the York Stairs with the Adelphi Beyond*, 1791.

'Paul Sandby is the only Man of Genius, he believes, who has employ'd his Pencil that Way' – 'that Way' being the taking of literal views, whether of country or town.

Paul Sandby's long career covers the second half of the eighteenth century. A remarkable innovator in his beginnings, by the time of his death in 1809 his work was already old-fashioned; in the meantime he had opened up new possibilities for English landscapists in the techniques of watercolour and print-making, though not of oil paint. In his grander watercolours he might profit from the example of Canaletto – a celebrated series of Windsor views, in the Royal Collection, are the finest of them – but the use of body-colour or gouache incorporated in the lacier effects of line and wash endowed his work with new substance and weight. In engraving, by his introduction of the aquatint technique in 1775, he enabled print-makers to produce a remarkably close tonal equivalent, and a little later a hand-coloured equivalent, to line-and-wash drawings or watercolours. Sandby was not however a specialist on the cityscape of London. His choice of subject-matter was generally very much in key with the fashion that entranced the attention of artists, connoisseurs and amateurs in the latter part of the eighteenth century: the appreciation of the picturesque. This involved the trapping – almost as if of butterflies in the entomologist's net – of those aspects of nature that seemed to compose

themselves according to the schemes of composition established by the great landscape painters of the past: Claude and Poussin – the classical idyllic; Salvator Rosa – the shaggy wilderness; then, more modestly, the rustic nooks and corners of the countryside, for which the admired ancestors were no doubt the Dutch painters of the seventeenth century, from Ruysdael to lesser masters, like Wijnants, both especially favoured by English connoisseurs.

The theory and, to some extent, the practice of the picturesque was expounded in the best-selling work of Dr Gilpin, his *Picturesque Tours* of natural beauty, published from 1782 on. The man-made order of urban brick and stone, the geometry of metropolitan squares and vistas, the subduing of sky into ceiling over a street corridor, these did not satisfy the taste for the irregular, the organic, the picturesque of nature. The great surge of accomplishment in that most English of media, watercolour, was concentrated on landscape ever more subtly suffused with atmospheric effects of light and shade. These ranged from J.R. Cozens's classicizing version of London from one of several artists' favourite viewing points, Greenwich Hill (p. 62), to the transient splendours of the fickle English weather, snatched down on paper as never before or since by Turner.

The demand for more prosaic topographical illustration and record was far from flagging. The development through the eighteenth century of the periodical publications, *The Gentleman's Magazine*, *The London Magazine* and others, as of the great quarto and folio county histories, and of illustrated antiquarian enquiries, produced a spate of topographical engravings. These varied in scale from the vignette and the small, octavo-page illustrations, to quarto and even full double-page spreads of folio size. Maybe most of the small periodical illustrations were coarsely executed in harsh black and white, crude summaries of the likeness of a place or a house, but by mid-century engravers of competence were active, commissioned by enterprising print-sellers like Robert Sayer and Henry Overton, who published excellent versions of Canaletto's views. These were often large, and handsome enough to be worth framing, but it is noticeable how they generally kept, as far as London subject-matter was concerned, to the aspects that were already traditional: the great royal palaces or town houses, whether in a bird's-eye view, or faced most often frontally, and always and above all the vistas offered by the slow curves and meander of the unembanked Thames. The Academician Joseph Farington, whose landscapes in oil can seem quintessential tedium, in his outline drawings could evoke a poetry of precision almost worthy of Canaletto. In another medium, aquatint, William Daniell produced a series of majestic prints of London vistas in the first decade of the nineteenth century (pp. 82–3).

When the watercolourists moved in from picturesque views of the

ABOVE **J.M.W.Turner**, *Moonlight, a Study at Millbank*, exh. 1797. Millbank, at the time of this painting, was a quiet riverside walk extending from Westminster almost as far as Chelsea Hospital.

RIGHT **J.M.W.Turner**, *Mortlake Terrace, the Seat of William Moffatt Esq. Summer's Evening*, exh. 1827. When this painting was first exhibited it was violently criticized for its yellowness. The critic of *John Bull* magazine likened Turner to a cook with a mania for curry: 'That the Lord Mayor's barge, which is introduced only for the sake of colour, should look yellow in its gingerbread decoration, is natural, and that the Aldermen's wives and daughters should look yellow, from sea-sickness, is also natural – but that the trees should look yellow, that the Moffatt family themselves, and all their friends and connexions, birds, dogs, grass-plots, and white stone copings of red brick walls, should be inflicted with jaundice, is too much to be endured.'

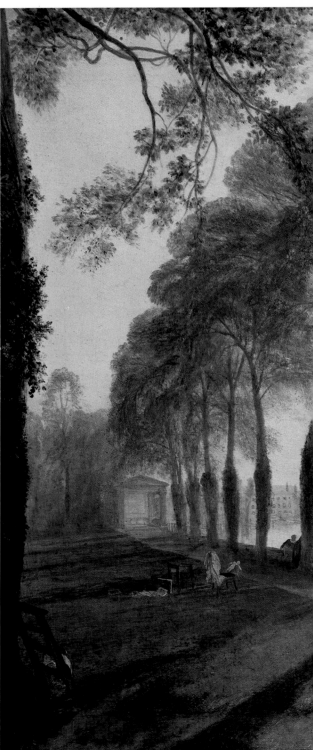

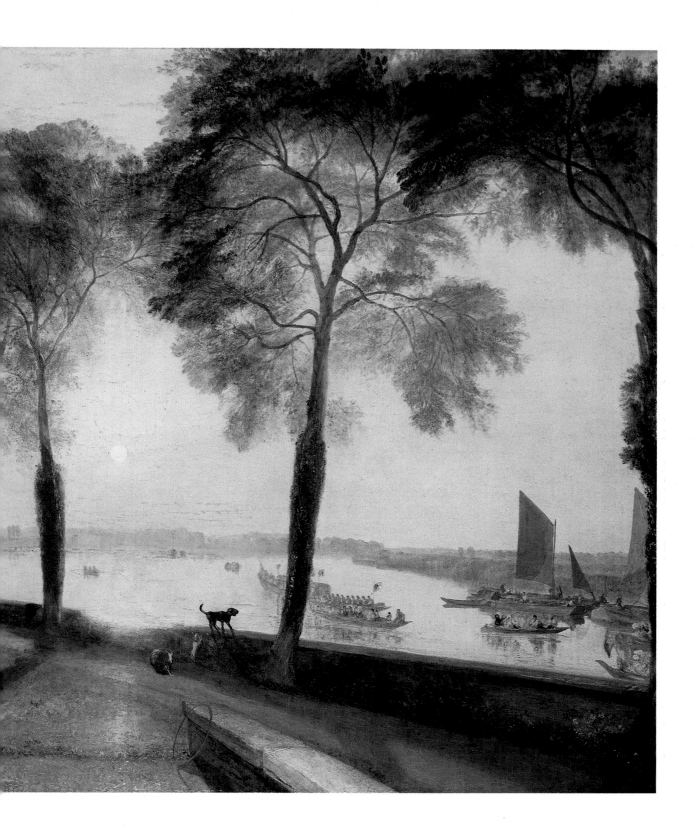

LEFT **James Miller**, *Piccadilly looking West*, 1775. The trees on the far side of the road must be ancestors of those that still shade Green Park, but Piccadilly itself looks very different.

RIGHT **Thomas Sandby**, *Beaufort Buildings*, 1725. The position of this street is now occupied by the entrance courtyard of the Savoy Hotel.

BELOW **Thomas Rowlandson**, *V* *ens,* exh. 1784. Many leading men society are included in Rowlandson's wa our of the most fashionable of the London pleasure gardens: in the right foreground is the Prince of Wales and 'Perdita' Robinson; in the centre Captain Topham, 'the macaroni of the day', is quizzing the Duchess of Devonshire. The gardens were finally closed in 1859.

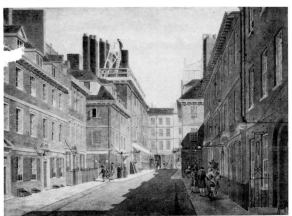

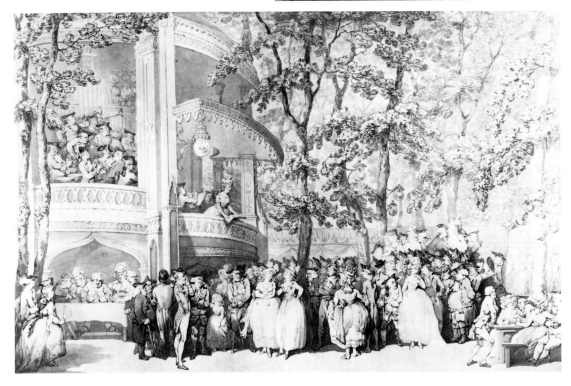

countryside to subjects nearer London, it was usually still to find picturesque nature. Such astonishment as these renderings may provoke in us nowadays is likely to be due to a sharp reaction of disbelief that the subject is correctly titled. Marylebone High Street, Islington, Kensington – even, most nostalgically, that ferocious race-track of traffic, banked by endless crudities of dead-eyed buildings that is now Tottenham Court Road – could find themselves identified in a rustic vision of barns and waggons, of rural ways through trees and fields of the unspoiled countryside. James Miller's drawing of Piccadilly in 1775, looking west at the corner of White Horse Street, breathes the fresh country air.

To find nature in the picturesque raw, the eighteenth-century artist, based perhaps in the Covent Garden area as many were, had only to probe a mile or so northwards. Even in Constable's time, in the 1820s and 1830s, the slope of the hill climbed north through green fields to the village of Hampstead and the wilderness of the Heath. London, sometimes described as a conurbation of villages that still retain their individuality within the metropolitan mesh, had yet to embrace what was to become Greater London even as far as Metroland.

The happy balance between London life and specific London fabric that Hogarth had created in *Morning* was not to be found again until the publisher Ackermann engaged Thomas Rowlandson to collaborate with A.C.Pugin in the *Microcosm of London*, starting in 1808. The *Microcosm* however is concerned primarily with figures in interiors, and is here reluctantly omitted. The most gifted and ferocious of English visual satirists, Gillray, rarely specified his settings, though his version of passers-by scanning the prints displayed in the shop of his publisher, Mrs Humphreys, at 27 St James's Street, in 1808 illustrates vividly how visual comment was broadcast in an age when there were no illustrated papers or advertisements, let alone photographs, films or television. Inevitably however, Sandby, and several of his contemporaries – the first wave of the great period of English watercolourists included such artists as Michael Angelo Rooker, S.H. Grimm, James Miller and Paul's elder brother, Thomas Sandby – did from time to time attend to metropolitan subjects. Thomas Sandby's account of Beaufort Buildings, well-built, well-maintained street architecture with desultory promenaders abroad in sunlit summer, not a glimpse of garden or a single leaf in sight, has essential urbanity. Paul himself produced some agreeable glancing views at odd corners of London, not least a charming survey of his own back garden (p. 63), as well as more traditional vistas. Rowlandson's great *tours de force* on London themes are the perennially delightful views of the great pleasure gardens of late eighteenth-century London – Vauxhall (p. 70), Ranelagh and the Spring Gardens. These had been favourite subjects for engravers throughout the century, but Rowlandson's

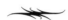

ABOVE **J.M.W. Turner**, *The Burning of the Houses of Parliament*, 1834. A watercolour study of the fire which destroyed the Old Houses of Parliament on the night of 16 October 1834. Westminster Hall was in danger of destruction too, but the wind changed direction in the nick of time.

RIGHT **J.M.W. Turner**, *The Burning of the Houses of Parliament, 16 October 1834*, exh. 1835. Turner executed two oil paintings of the event which he had witnessed in person. This version includes the crowds which were so great that the army was called in to help the police control them.

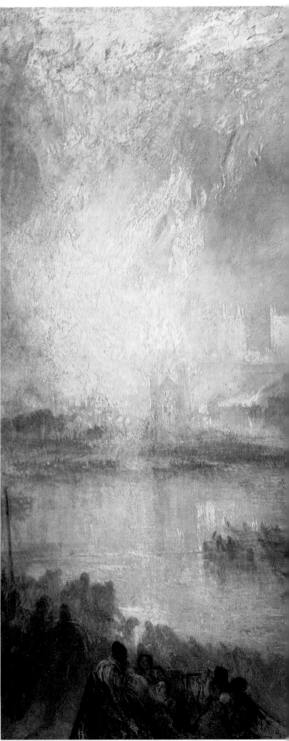

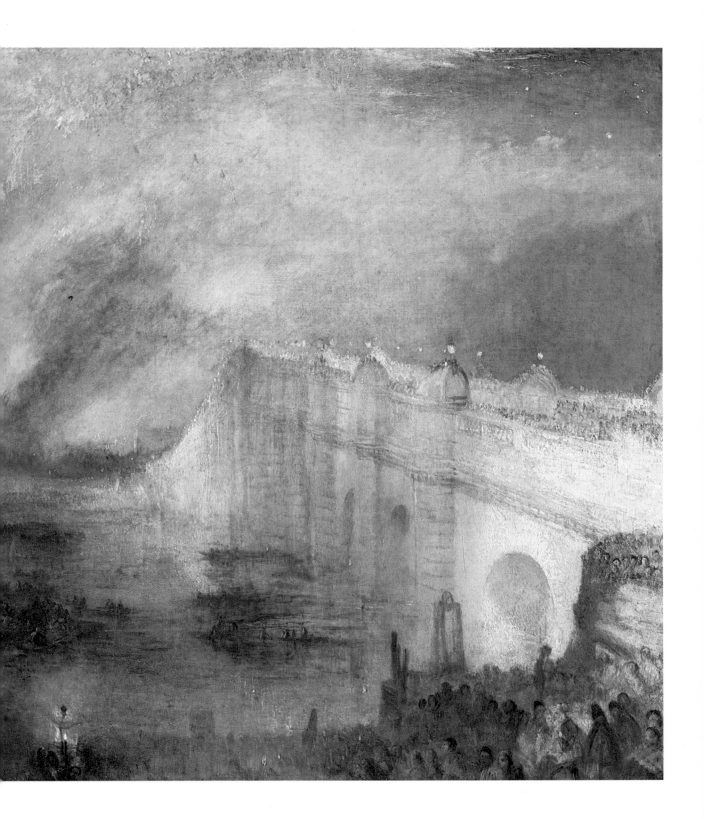

Thomas Malton, *The Mansion House, with a View up Cheapside*, 1783, from *A Picturesque Tour through London and Westminster*, 1972. Mansion House, the first official mayoral residence, was built between 1739 and 1752 to designs by George Dance. In the distance St Mary-le-Bow can be seen, and the projecting clock of St Mildred Poultry.

inspired and unblinkered view of the fallibility of fashionable elegance and the extravagances of ageing flesh was uniquely his own.

The parks also offered a ready subject. There is a vividly illuminating contrast between the view of St James's Park offered by George Lambert (pp. 58–9) and that by Gainsborough (p. 65). Lambert, if it was he, records in about 1735 two aristocratic exquisites gossiping, overlooking the park, on a terrace of what is now No. 10 Downing Street. There is a precise garden within the brick wall, gardeners tend somewhat regimented nursling plants and, beyond the wall, trees border the ruler-straight line of the canal like guardsmen. But the path to the right would have led you in only a few hundred yards to the Mall, along the north side of the park, to where Gainsborough, in 1783, sited his most ethereal dream of fair women. 'To the connoisseur,' observed a commentator, 'the most compendious information is to say that it comes nearest the manner of Watteau, but to say no more it is Watteau far outdone.' It incorporates elements of other Gainsborough landscapes, but retains no doubt something of the Mall, as it literally was, doubtless, like Watteau, 'far outdone'. The obliging cow, purveyor of fresh milk, was still around, descendant no doubt of the one seen in Charles II's time.

By the last decade of the eighteenth century the expression picturesque, while becoming the subject of abstruse controversy as to its essential meaning, was being generally fairly loosely applied, not necessarily in terms of Gilpin's orthodoxy, and so became attached to London. This is signalled by one of the handsomest books on London's topography ever published, Thomas Malton's *Picturesque Tour through London and Westminster* of 1792, the same year indeed that Gilpin's seminal *Three Essays on Picturesque Beauty, etc.* was published. In Malton's illustrations the picturesque of London is of mainly eighteenth-century metropolitan architectural decorum, seen down slanting views in clear weather, animated by figures and traffic of more or less sprightly propriety.

THE NINETEENTH CENTURY

THE LONDON OF THE TWO SUPREME English masters of landscape – Joseph Turner and John Constable – is remarkable mainly for its non-existence, with a few exceptions of a rather specialized nature, though both artists could justifiably be labelled as Londoners: Turner by birth (in Maiden Lane, just west of the hurly-burly of Covent Garden), and Constable by long residence (from around 1800 until his death in 1837). Turner's base was always London, though he moved around between central London, Hammersmith and Chelsea where he was to die. Early on in his career, when testing out his skills against those of the Old Masters, he treated a London view in the manner of Vernet: *Moonlight, a Study at Millbank* (p. 68) was one of his first experiments in oil and was exhibited at the Royal Academy in 1797. But his art was nourished by his journeys outside London, through England and Wales, and abroad. It is entirely typical that one of his few early London drawings (of 1792), executed with the detailed precision that was then required of topographical draftsmen of architectural and antiquarian subjects, should be of holocaust, or at least the results of it: *The Pantheon, the Morning after the Fire* (p. 78). The idylls of the semi-rural *banlieue* of London, particularly of Thames-side, could arouse him as they did many others, including Richard Wilson, but Turner's pastoral meditations on Mortlake (p. 69) or on the Twickenham of Pope's Villa suggest an earthly paradise. The subject that moved him to exultation, kindling colour in watercolour across the pages of notebooks and orchestrated into great echoing chords in oils, was, following the promise of his drawing of the Pantheon forty years earlier, the conflagration that suffused the dark with liquid fire and smoke when the Houses of Parliament at Westminster burned on the night of 16 October 1834. In his maturity, Turner's essential subject became ever more the violence of the elements, above all of light that both creates and destroys, like the God Shiva. For Turner light, without which nothing is visible or has existence in the eye, also dissolves the substance of all that it touches, until in his latest work he can seem to paint pure incandescence. In his studies of the burning of the Houses of Parliament (pp. 72–3), relatively early though they come among the revolutionary experiments of his last years, the subject – as it were the fabric of government itself going up in flames – aroused him to awe-inspiring grandeur. Some now doubt that when out that

75

John Constable, *A View of London with Sir Richard Steele's House*, exh. 1832. This view was painted from what is now Haverstock Hill looking across St Pancras and Islington to the City where the skyline in the 1830s was still dominated by St Paul's. Sir Richard Steele, the essayist and politician, retired in 1712 to the small house in the right foreground.

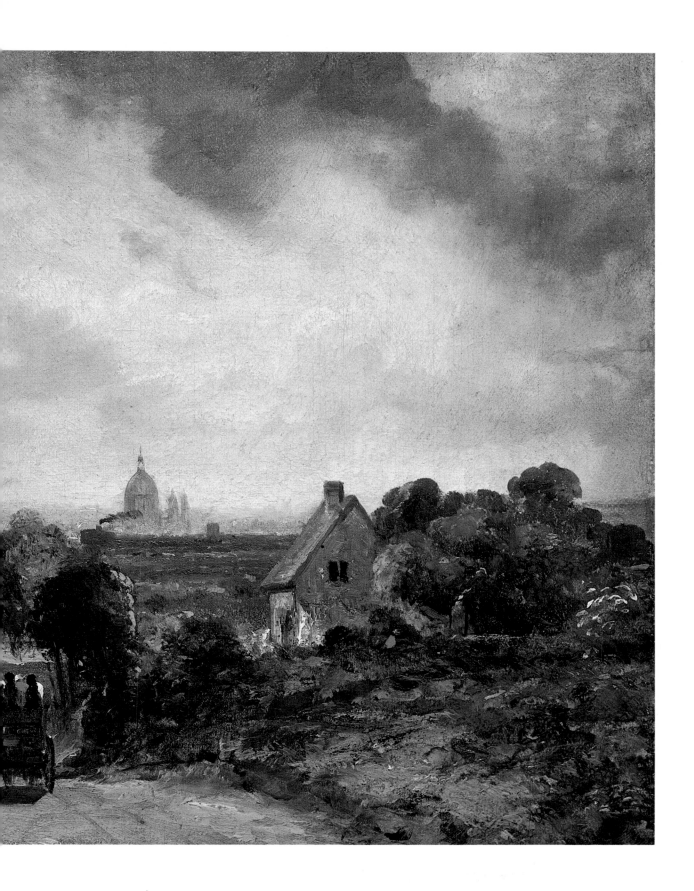

RIGHT **J.M.W.Turner**, *The Pantheon, the Morning after the Fire*, 1792. James Wyatt's finest building was the Oxford Street Pantheon, built between 1770 and 1772 as the Vauxhall or Ranelagh of the West End.

BELOW **John Constable**, *Fire in London from Hampstead*, 1826? Little is known about this sketch, or the fire that it records – a subject which Constable, unlike Turner, pursued no further.

BELOW **John Constable**, *The Opening of Waterloo Bridge, 18 June 1817*, exh. 1832. The Prince Regent is shown embarking from Whitehall Stairs, next to Fife House, then the residence of the Prime Minister Lord Liverpool, for the short journey up river to open the new Waterloo Bridge, designed by John Rennie.

night he could have worked on the spot in watercolour in his notebooks, but his memory was tuned to formidable accuracy. The bridge rises but then seems to collapse on the far bank into the conflagration; the twin towers of Westminster Abbey's west front, seen ghostly through the main cauldron of fire, are vital props, faint though they be, without which the whole composition would dissolve upon itself, as the Palace of Westminster was in the process of doing.

Constable, based from 1821 in Charlotte Street, to the north of Soho, found London as a subject unrewarding, and said so. On 21 November 1823, in a letter to his wife from the rural peace of Sir George Beaumont's estate at Coleorton, he wrote that in contrast 'In London nothing is to be seen, worth seeing, in the natural way ...'. His work connected with what is now London relates almost always to Hampstead and Hampstead Heath, which in his time were not yet embraced by the Great Wen. Hampstead was still a country village, and Constable's sky studies and his views of the country there rarely even hint at London's ominous proximity. From 1827 Constable had a house of his own there, in Well Walk, but he had spent much time in the village in rented accommodation from 1819 on. There are a few oil and pencil studies of Hampstead's village nooks and corners, and the well-known, small but superb oil-painting of *The Grove, Hampstead*, also known as *The Admiral's House*, in the Tate Gallery. His *A View of London with Sir Richard Steele's House* (pp. 76–7), looking downhill to the London skyline, is an exception, but is chiefly remarkable for its marvellous evocation of unsettled weather. There is one hint of excitement at the subject – major conflagration – that was to inspire Turner: a tiny sketch, now in the Mellon Collection, of the silhouette of St Paul's dome stark against an incandescent sky. It would be nice if this were indeed Constable's reaction from afar to the same spectacle – the burning Houses of Parliament in 1834 – that aroused Turner, but the location of the fire is different and the sketch may well relate to a recorded but lost sketch of a fire in London seen from Hampstead in 1826. Unlike Turner's, the initial reaction was developed no further.

There was one spectacular event in London which did catch and hold Constable's attention to such effect that he worked on his version of it over many years, even if sometimes *à contre-coeur* and in frustration. This was the opening of Waterloo Bridge by the Prince Regent, which occurred, amid waterborne junketings that would have enchanted Canaletto, on 18 June 1817. Related sketches go back to at least 1819, but a full-scale version seems not to have been begun till about 1825. When Constable at last submitted his finished painting – one of his 'six-footers' – for exhibition at the Royal Academy in 1832, he was still fretted with doubts: 'I have never had more restlessness

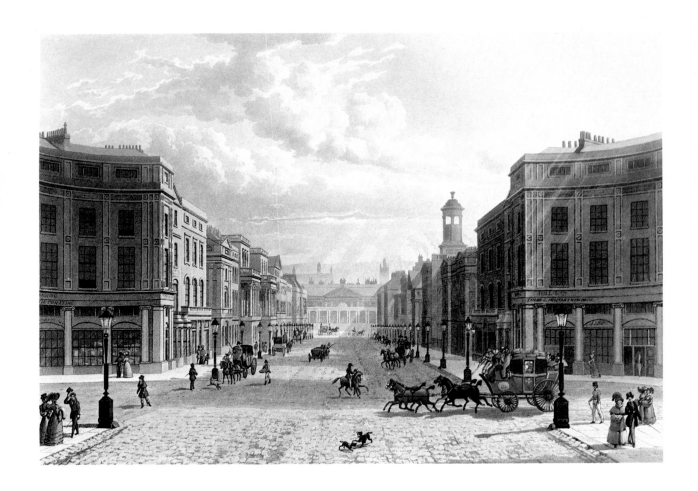

T.H.Shepherd, *Regent Circus*, 1822. Shepherd's aquatint shows Regent Circus (now Piccadilly Circus) looking south towards Lower Regent Street and Carlton House. The circus was part of John Nash's great scheme to link Regent's Park to the Prince Regent's mansion, Carlton House, which was however demolished in 1829, a few years after the scheme was completed. The elegant lamp-standards are a reminder that by 1822 gas lighting was becoming quite common in the West End.

about a picture, than with the premature dismissal of this,' – he evidently felt that even after all those years it was still not to his satisfaction – 'and it has not my redeeming voice ["the rural"]'. Even after that, Constable continued to work on the subject almost up till his death in 1837. The surviving drawings and sketches, ranging from high-level to almost water-level variations, witness his problems; though the final canvas is of considerable panache and grandeur, it is not the most compelling of his majestic 'six-footers', perhaps because he had worked too long on it, but perhaps also because the tumult of so much metropolitan brouhaha was indeed alien to his sympathies.

The London of 1800, as far as its fabric was concerned, was somewhat in the doldrums, the economic demands of the French wars having inhibited much extravagant building. But already well before Waterloo in 1815, with the establishment of the Regency in 1811, a great plan was emerging for imposing an order worthy of the metropolitan – the imperial – capital on the maze-like warren of London. Though the use of painted stucco was already popular, the bulk of London was certainly brick, and it was into brick's texture that John Nash opened up a shining stucco regal, or anyway Regent's, route: the new road from the Regent's palace at Carlton House in St James's Park, through the slums of Soho, north a mile or so to Regent's Park, which was to be fringed by three spectacular terraces, stage-sets almost, of classic elegance. Of that grand design Sir John Summerson has observed: 'Once, and only once, has a great plan for London, affecting the development of the capital as a whole, been prepared and carried to completion.'

Neither this planned regal sequence – Regent Street linking south to north the two parks – nor the earlier regular but, it must be admitted, in its formidable extent, tedious proliferation of late Georgian terrace housing ('two windows iron railing and a door . . . two windows iron railing and a door'), inspired either Constable or Turner. On the other hand, where London offered a clarity and clean linear urbanity, it did attract some of those who in a somewhat contrary tradition, that of Canaletto, roved London in search of rewarding visual fare. So Thomas Shotter Boys, owing something to Canaletto (with a strong dash of Bonington, with whom Boys was intimate in his early days), in the twenty-six plates of *London as it is* (1842) recorded lively elegance in the early Victorian city (p. 82). Unlike his Paris views, which were chromolithographs, Boys used for his London set monochrome lithographs, sold plain or hand-coloured (though plain ones are now rare, and most have had their colour added later, or at least 'freshened up' in the art trade). His mastery of space and light – the handling especially of emptiness whether at ground level or in the sky – was matched by a delicate accuracy in architectural detail, and enlivened by a

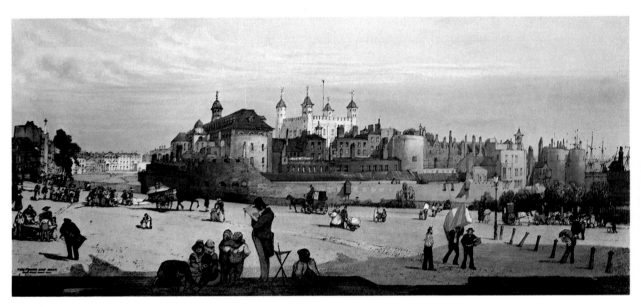

ABOVE **T. Shotter Boys**, *The Tower of London and the Mint*, 1842. Shotter Boys's lithograph of the Tower shows the Byward Tower on the extreme right, the Beauchamp Tower in the centre and the Devereux Tower on the left. In the background to the left is the Mint, designed by John Johnson and completed by Sir Robert Smirke. It was not until 1810 that coinage was moved there from the Tower. The figure sketching in the foreground is thought to represent Shotter Boys himself.

RIGHT **William Daniell**, *A View of the East India Docks*, 1808. By the beginning of the nineteenth century London had become the commercial centre of the world. Between 1800 and 1805 four huge London docks were built: the West India Docks, the London Docks, the Surrey Docks and the East India Docks. The construction of the West and East India Docks, both in Poplar, caused such an inrush of people to the area that in 1817 Poplar had to be divided from Stepney and made into a separate parish.

RIGHT ABOVE **George Scharf Sr**, *Montague House*, 1848–9. Montague House was used to display the collection which Sir Hans Sloane left to the nation in 1753. By the early nineteenth century the collections, including the Elgin Marbles, were increasing to such an extent that in 1821 it was decided that a new building should be put up to house them. The British Museum was begun in 1823 to designs of Sir Robert Smirke; Montague House was gradually demolished to make way for the museum's present front and façade.

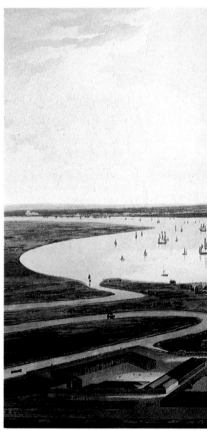

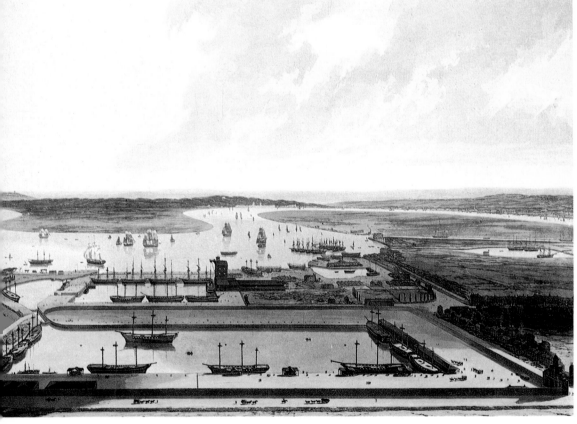

charming quasi-anecdotal delight in the presentation of groups of figures. He produced a London as lively as Rowlandson's, but an up-market version that was always defined in precise location: a civilized city, animated, but free from violence and exaggeration. And free of fog. Perhaps he portrayed an ideal, but it is one that remains enduringly desirable, as the endless popularity of framed reproductions of his London views confirms. Its range is indicated by the amplification of the title of *London as it is ... Principal Streets and Characteristic Accessories. Public Buildings in Connexion with the Leading Thoroughfares etc. etc.*, continuing the tradition of Malton's *Picturesque Tour*.

Shotter Boys was the outstanding practitioner of that time, but he was far from alone. Of industrious competence, but of less imagination let alone inspiration, were the unflagging ubiquitous members of the Shepherd family, whose faithful accounts of London architecture illustrating works like Elmes's *Metropolitan Improvements* (1827–31) ranged far beyond the topographical limits observed by Shotter Boys. At their best, the Shepherd records evoke a wondering nostalgia. Thomas Shepherd's view of Regent Circus in 1822 looks down the slope to where Carlton House was still standing: the variety within decorum of Nash's concept, the marvellous relaxed tempo of the few citizens promenading in the late afternoon street, the stylish discretion of the street furniture (elegantly uniform street lamps only) and the shop fronts – all these must cause a pang in the breast of anyone accustomed to fighting their way in the rush-hour across this same spot, now Piccadilly Circus (p. 80).

By the time, 1842, that Shotter Boys produced his *London as it is*, the monopoly of the artist in the provision of topographical record of London was already threatened. Fox Talbot's *The Parcel of Nature* (1844) was the first book to be illustrated by photographs, and had been preceded, in 1840, by a French

publication, *Paris et ses Environs reproduits par le Daguerrotype.* Though in the latter book the photographs still had to be transposed into lithographs, the future role of the camera was clearly announced. However, photography would take some time yet before attaining the mobility and flexibility of the peripatetic artist, let alone his ability to use colour, and meanwhile topographical artists still found employment. Novelties inspired some: for example, Hakewill's lithograph of the new zoo in Regent's Park (1831), a fresh variation on the London pleasure garden theme. The picturesque of the old survived too, and C.R. Stanley's view down the Strand to St Clement Danes and St Mary-le-Strand has a modest, almost rustic air, for all that the Strand was at that point (about 1824) one of the principal shopping streets in London.

These are just samples of the kind of work being produced in some quantity by a number of competent native-born artists in London around the second quarter of the nineteenth century. They were supplemented by an increasing number of visiting artists, some staying briefly, some settling for good. One of the settlers was the German George Scharf, who was to specialize in views of London, many in lithographic form. (His son, Sir George Scharf, was to be first Director and virtual founder of that most English institution, the National Portrait Gallery.) Scharf the elder's view of Montague House (p. 83) is a glimpse of what was then the British Museum, soon to be demolished and replaced by Robert Smirke's great neo-classic building. Another foreigner who had a long

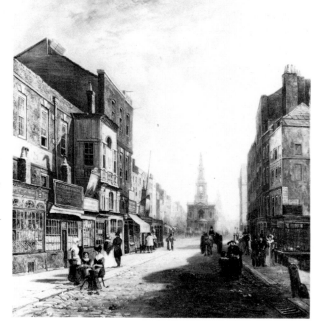

C.R.Stanley, *The Strand, Looking Eastwards from Exeter Change*, c. 1824. Stanley's view shows, in the distance, that splendid pair of churches marooned on an island surrounded by traffic: St Mary-le-Strand, built by James Gibbs between 1714 and 1717, and St Clement Danes, designed by Wren, with a spire added by Gibbs in 1719. By the time of this painting the Strand was one of London's main shopping streets.

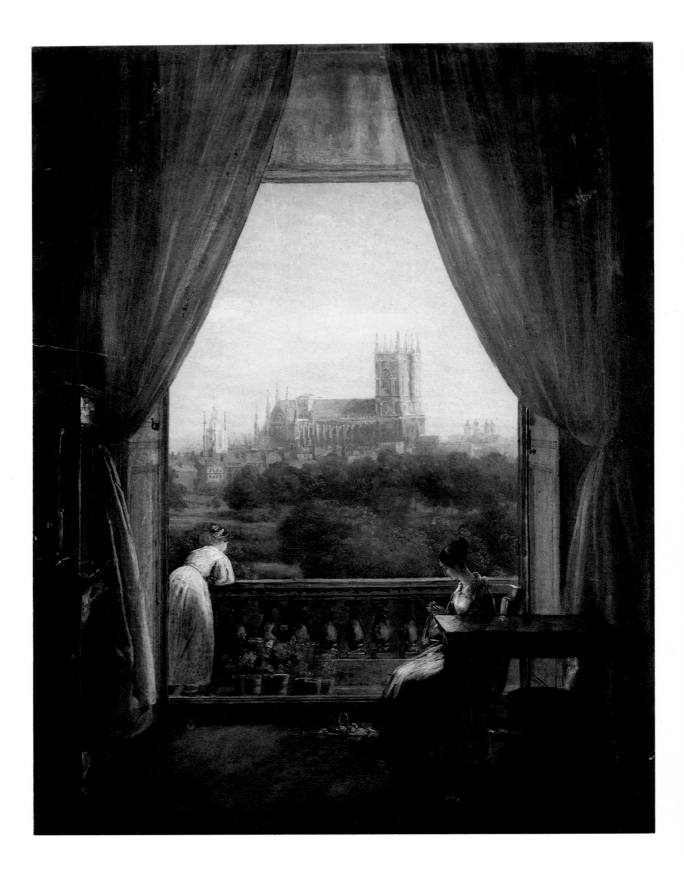

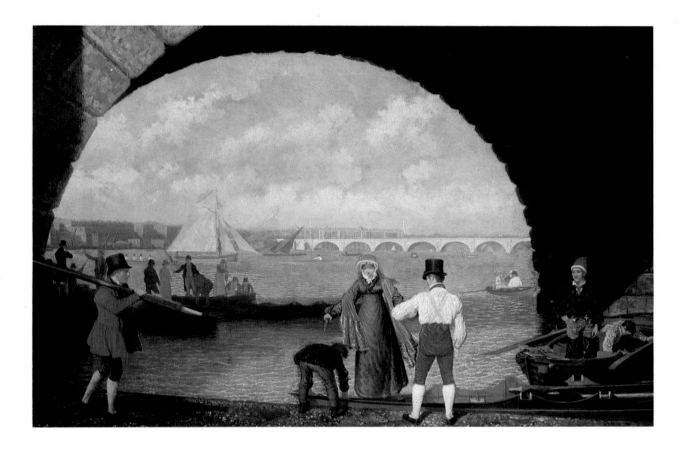

ABOVE **Jacques-Laurent Agasse**, *Landing at Westminster Bridge*, 1817–18. The new Waterloo Bridge, designed by John Rennie and opened by the Prince Regent on 18 June 1817, can be seen through an arch of Westminster Bridge (c.f. Samuel Scott's painting, *An Arch of Westminster Bridge*, pp. 6–7). Rennie's bridge was demolished in the 1930s and replaced by the present structure designed by Sir Giles Gilbert Scott.

LEFT **Louis Pierre Spindler**, *London Interior, c.* 1834. Westminster is the centre of the national legislature and the executive, yet within its boundaries the dense fabric of building is uniquely intermeshed with the open spaces of its parks. Here two aristocratic gentlewomen, Lady Canning and Lady Waterford, are poised in genteel contemplation at a window high in Carlton House Terrace looking out over the Mall and the tree-tops of St James's Park to Westminster Abbey, with the turrets of St John's, Smith Square, on the right, and, on the left, St Stephen's Chapel, shortly before the residence of Parliament burned in 1834.

career in England was the Swiss Jacques-Laurent Agasse, sometime pupil of David in Paris, but also an admirer of George Stubbs. His cool and objective vision is admirably exemplified in his variation on a theme of Canaletto's and Scott's: a river view seen through a bridge's arch (p. 87). In Agasse's painting of 1817–18, he is looking through Westminster Bridge upstream to the newly opened Waterloo Bridge, the subject over which Constable, from a different angle, agonized for so many years. Another brief visitor was L.P.Spindler from the Rhine Valley, also a product of the Parisian schools. A charming view of his from within a spacious drawing-room above the Mall looks over St James's Park to Westminster Abbey, with the four turrets of St John's, Smith Square, beyond an evocative metropolitan afternoon rêverie, the pensive inhabitants being the Ladies Waterford and Canning. Visitors from France came in some strength, and were to continue to do so. They ranged from Théodore Géricault, who drew London faces and Epsom horses but not the city's fabric, and Eugène Delacroix, to the brilliant cartoonist Henri Monnier, who again drew London men and manners but not its architecture, and the chic and stylish Eugène Lami who made dashing watercolours of early Victorian high life in smart places. In the Fitzwilliam Museum, Cambridge, a little sketchbook preserves enchanting glimpses of London by Carl Hartmann, pencil and wash on grey paper, all done in a visit of 1847. For such visitors what was in many cases no doubt ordinary and uninteresting to the native Londoner was a fresh and exotic surprise.

There was however another London, or other Londons: the London of hideous slums; the London in relentless expansion, of which Cruikshank's

Carl Hartmann, *Nelson's Column* from *A London Sketchbook*, 1847. The statue of Nelson, 17 feet 4½ inches high, by E.H. Baily, was raised on its fluted Corinthian column in 1843. The column of Devon granite was designed by William Railton and erected in 1839–42; including Lord Nelson, it stands 185 feet high.

Eugène Lami, *View of London*, *c.* 1850. Lami painted this water-colour of Trafalgar Square as seen from Pall Mall during his visit to London in 1848–52.

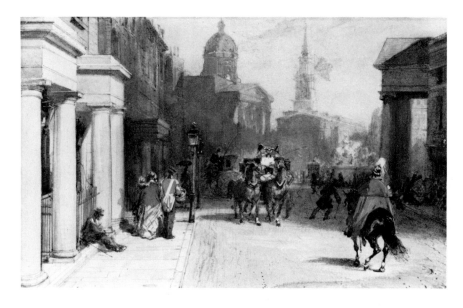

etching of as early as 1829. *London going out of Town – or – The March of Bricks & Mortar* (p. 92) offers vivid comment: and the London cut open in huge swathes by the invasion of the railway lines thrusting to the new giant termini all through the mid-nineteenth century. The ravages and reconstructions of the railway enterprises are documented in many spare and rather weird prints, sometimes reminiscent of major archaeological excavations in a city of the past, sometimes of mass slave-labour producing the modern equivalent of the Pyramids (p. 93). There are records of the nascent steam-locomotive, cherishable as an archaic toy, but on the whole – in spite of Turner's famous celebration of *Rain, Steam and Speed – The Great Western Railway* (1844) – the London railways and their majestic termini (to the nineteenth century 'what monasteries and cathedrals were to the thirteenth century', observed the *Building News* in 1875) did not attract the more important artists. There is no London counterpart to Monet's *Gare St Lazare*: in contrast to that marvellous transposition of steam, speed and train-shed into molten light and colour, Frith's well-known *Paddington Station* seems merely an anecdotal contrivance. On the other hand, as we shall see, when Monet came to paint London, it was (besides the sempiternal dialogue of river and sky) Victorian London that he painted, not the obvious picturesque of earlier times.

The actual march of endless suburb offered little except where it still retained enclaves of traditional rural or village picturesque. The roofscape was for mile on mile virtually that noted by Hollar in the early seventeenth century in a preliminary drawing (p. 29) for his panoramic view multiplied *ad infinitum*.

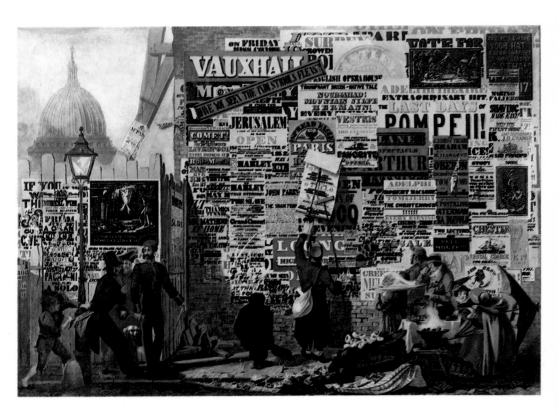

ABOVE **John Orlando Parry**, *London Street Scene with Posters*, 1835. The artist of this painting is almost unknown (perhaps he was a scene painter), but his picture is a singularly vivid record of a corner of London in that dishevelment of transition which is a continual condition of the capital – the dome of St Paul's, however, lending an assurance of permanence beyond. The scene is positively Dickensian in feeling (*The Pickwick Papers* began publication the year after this picture was painted).

RIGHT **I.J.Borgnis**, *The Metropolitan Baths, Shepherdess Walk, Hoxton, c.* 1845. Shepherdess Walk lies in a part of London, between the City Road and Regent's Canal, which began to be developed at the end of the eighteenth century. The terraced houses, partly stuccoed and with iron balustrades, are typical of those built in the inner suburbs in the early nineteenth century. The Metropolitan Baths were a rather elegant private bathing establishment opened in 1835.

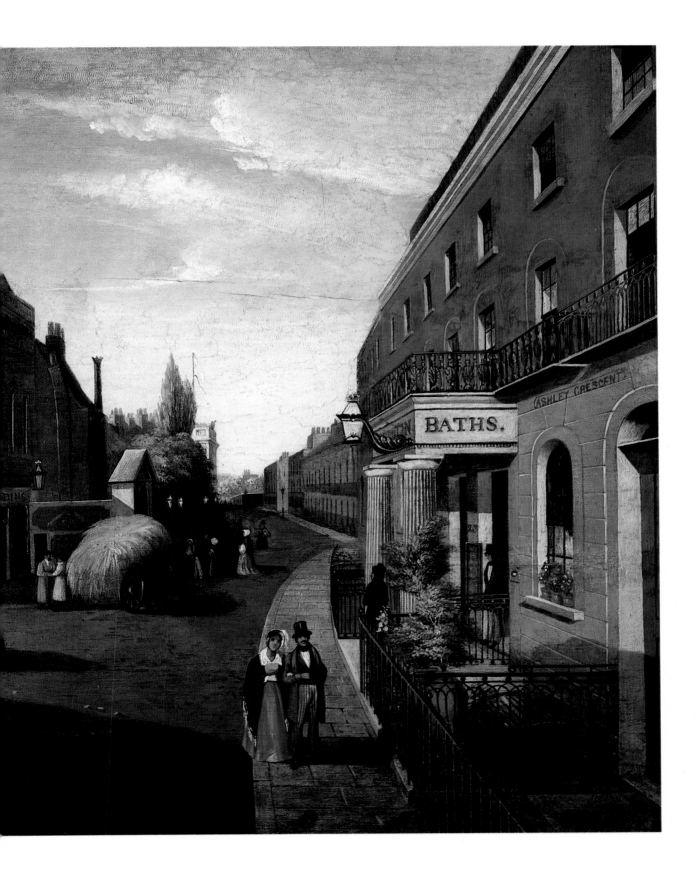

Nevertheless, occasional 'primitive' views of the suburbs crop up, sometimes enormously engaging, like that by one I.J. Borgnis (otherwise unknown) recording the Metropolitan Baths, Shepherdess Walk, Hoxton, around 1845 (p. 91). The street, standing between the City Road and Regent's Canal, has a rural air, although in an area already urban. Quite extraordinary is a very accomplished documentation, signed by John Parry, of a street scene in a state of arrested development, perhaps even a precocious specimen of that widespread twentieth-century ailment, 'planning blight': a collage of bill-posting, somewhere close to St Paul's, dated 1835 (p. 90). Although pre-Victorian, it is prophetic of the endless reshaping of the City that was to accelerate remorselessly through the century.

By the mid-1850s however the names of London's major artists were on the horizon. The American, James Abbott McNeill Whistler, stopped off briefly in Knightsbridge on his way from Washington to Paris in 1855 when he was twenty-one. By 1860, though by then he had acquired French affiliations that he never lost, he was settling in London, and it was there – after many excursions from the city – that he died forty-three years later, to be buried in Chiswick Cemetery (not all that far from the grave of the quintessential Londoner, Hogarth). His early London etchings, or a painting such as the well-known *Wapping* (1860–4), concentrate on the working aspects of London, of Thames-side as a great commercial port. They answer, if still only on a limited selection of the possibilities, Baudelaire's demand that artists turn to subjects that reflect modern life. Baudelaire discerned in Whistler's London etchings 'the profound and complex poetry of a vast city' (1862). The etchings of wharves, warehouses, factories and barges, the clutter of masts, ships and rigging (p. 96), scorned the traditional picturesque, celebrating even squalor at times. His

George Cruikshank, *London going out of Town – or – The March of Bricks & Mortar!*, 1829. Cruikshank's satire on the erosion of the countryside by London's expanding suburbs comes from his *Scraps and Sketches* (1828–33).

John C. Bourne, *Building the Retaining Wall, Camden Town* from *Drawings of the London and Birmingham Railway*, 1839. Robert Stephenson was the overall engineer of the London–Birmingham Railway, built between 1834 and 1838.

approach to his subject-matter at this point clearly owes something to his admiration for and friendship with Courbet, the genius of French realism. His increasing dissatisfaction with that movement, coupled with his discovery of Japanese prints and an insatiable fascination with the possibilities of the most delicate modulation of tonal values, was to find resolution in the lifelong study of the moods, in London mist or dusk, or even the river night, of the reaches of the Thames, seen most often from Chelsea or Battersea (p. 94). These views often depend for their stability on a scatter of accents, glints of light or darker verticals offered by the pier of a bridge or factory chimneys on the far bank. Even if it is sometimes uncertain whether the subject relates to London, Southampton Water or some other riparian view, in general his paintings revealed a hitherto unformulated London poetry to London's citizens. So in 1882 the *Athenaeum's* critic (not earlier noted for sympathetic response to Whistler's imagery) confessed of a *Nocturne: Blue and Silver – Cremorne Lights* (pp. 10–11) that it rendered 'with exquisite gradations and *perfect truth* [my italics] one of those lovely effects of dimly illuminated morning mists on the Thames which Nature evidently intended Mr Whistler to paint'. As Whistler himself, responding to a compliment that a similar effect was like a Whistler, agreed: 'Nature is creeping up.' Although his increasing use of musical titles for his paintings ('Symphony', 'Nocturne', 'Arrangement') emphasized his insistence on the formal values of his compositions over and above their subject-matter in nature, his name evokes ineluctably moods that Londoners

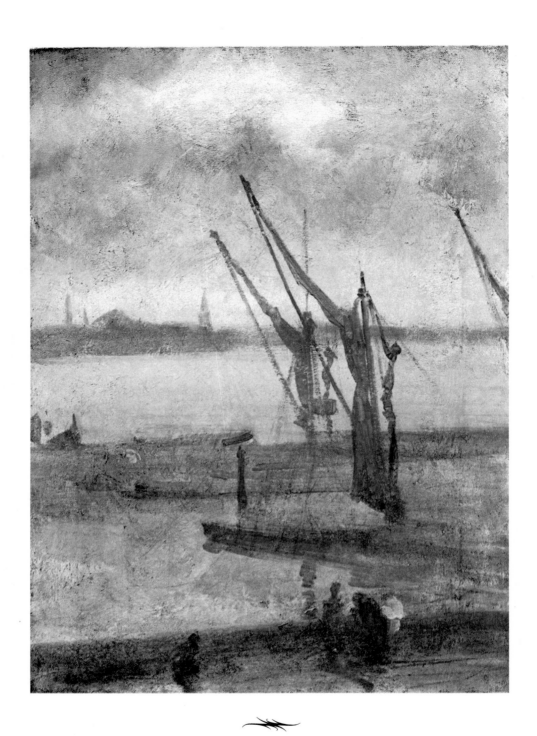

ABOVE **J.McNeill Whistler**, *Grey and Silver: Chelsea Wharf,*
c. 1864–8. Looking across the water – with the wall of the
Chelsea shore and a few vague figures in the foreground –
the loosely furled sails of Thames barges gesturing against
the soft grey tones of the river, the far bank and the misty
sky.

RIGHT **J.McNeill Whistler**, *Nocturne in Black and Gold: The*
Falling Rocket, 1874. After seeing this painting, inspired by a
firework display in the Cremorne Pleasure Gardens, John
Ruskin wrote: 'I have seen, and heard, much of Cockney
impudence before now; but never expected to hear a
coxcomb ask two hundred guineas for flinging a pot of paint
in the public's face.'

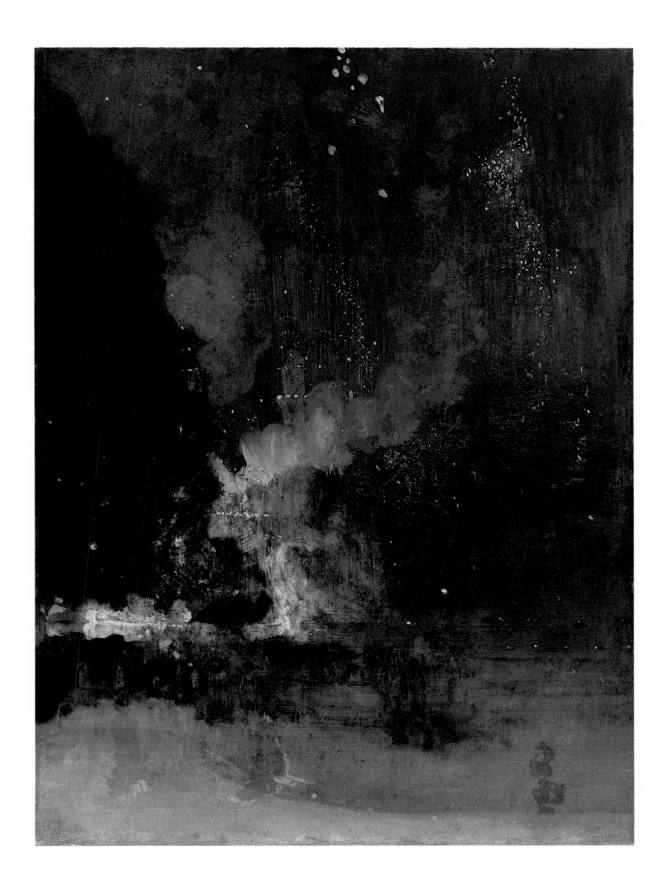

J. McNeill Whistler, *The 'Adam and Eve', Old Chelsea*. Whistler's etching of riverside houses in Chelsea is named after the Adam and Eve Inn. The church and surrounding houses were very badly blitzed in 1941.

can feel belong peculiarly to London and its river, even though from them one would not guess that the mammoth embankment project of the Thames had altered its character, nor hardly that it had been spanned, by the time of Whistler's death, by so many more massive bridges.

Whistler's ventures inland into the more solid texture of the city were few in comparison – some lively and atmospheric etchings, mainly of the Chelsea area with one or two further afield, even an aerial view of St James's. A favourite motif in painting was supplied by shop windows, perhaps two or three in a row, observed four-square from the opposite side of the road, but glowing rich with subdued colour as stained-glass windows: these often seem to anticipate the more two-dimensional patterning of much twentieth-century painting, the rectangular shapes of the windows in the façades supplying a firm structure for the play of colour and tone. One of his most famous paintings, *Nocturne in Black and Gold: The Falling Rocket* (1874) was apparently the picture likened by Ruskin to the flinging of a pot of paint in the face of the public, a comment that provoked Whistler to the famous libel action, when the painter was awarded a farthing damages against the critic, but was bankrupted by the legal costs. The painting (p. 95) was inspired by a firework display in the Cremorne Pleasure Gardens, but might seem at first glance a painting of the New York Abstract-Expressionist school, though its closest, perhaps unexpected, parallels are the pyrotechnics that Monet in extreme old age improvized on the theme of Leicester Square at night (p. 129). Close though Whistler's contacts and affections for France remained, he was never properly of the Impressionist school, never for example in his later painting working direct from nature, and

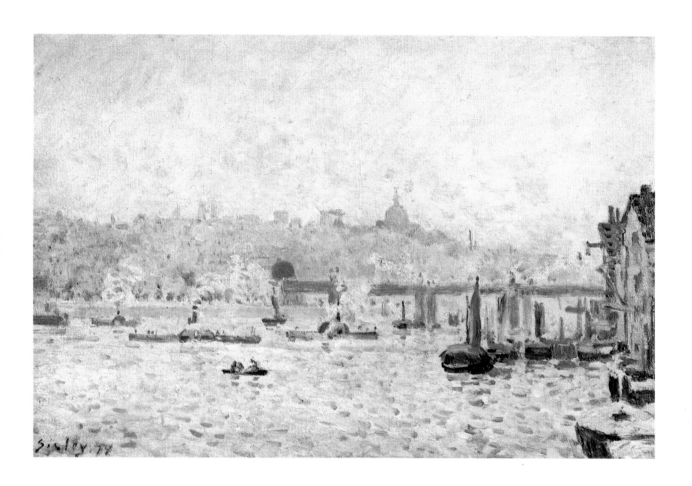

Alfred Sisley, *View of the Thames*, 1874. The artist apparently mistitled this painting, calling it a *View of the Thames and Charing Cross Bridge*. Unless it is a *capriccio*, which it does not appear to be, it must have been painted from the south bank looking northeast, over Cannon Street Railway Bridge towards the dome of St Paul's on the skyline.

97

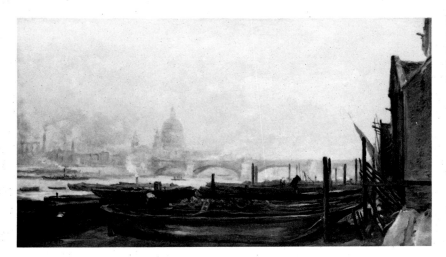

Charles Daubigny, *St Paul's from the Surrey Side*, 1873. A very moist and airy view of the Thames, capturing the feel of the river air, and almost conveying its smell.

never involved in the analysis of colour as developed by Monet and then Seurat.

The first influx of the true Impressionists was precipitated by the Franco-Prussian War, the Siege of Paris, and the revolution of the Commune, in 1870–1. But even before that Corot had come to London for a week in summer 1862, and Daubigny in 1866 when he painted the Houses of Parliament, very murky and moist, in some respects anticipating the buildings' looming quality as painted by Monet forty years later. Daubigny was back again in 1870, seeking refuge; on 15 October, in Kensington, he stopped writing a letter to light a candle: 'It's eleven o'clock in the morning. So much for the climate. Fog. Visibility less than two paces!' Though his view of St Paul's from the south bank derives from studies made on this trip, London otherwise seems not to have stirred him; his attention was focussed further down the estuary where no doubt the visibility was better.

François Bonvin was another to arrive in 1870, a few weeks after Daubigny. Writing from London on 12 November he too recorded: 'the first thing to greet me is an unusually thick fog ... the fog is ruining my sight'. Bonvin, friend of Courbet, was primarily a painter of realist genre, but there survives from his year's stay in London a singularly sensitive view of Waterloo Bridge, as seen by a solitary figure brooding at the river wall.

The two most famous painters of the Impressionist movement to stay any length of time in London had arrived a little earlier in the autumn of 1870: Claude Monet and Camille Pissarro. If in conversation or letters neither were to record much affection or gratitude for the country that gave them refuge, that is understandable for it was to be a very long time before England acknowledged the genius of their art. Both submitted pictures to the Royal Academy in 1871,

François Bonvin, *Waterloo Bridge*, 1871. Bonvin was another French artist who sought refuge in London from the troubles of the Franco-Prussian War and the Commune. This is a relatively rare excursion into landscape by an artist best-known for his genre and still-life paintings, who was the finest of the nineteenth-century followers in the tradition of Chardin.

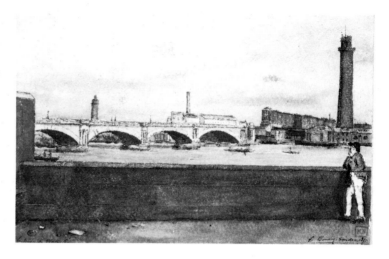

and both were ('naturally', commented Pissarro later) rejected. They were apparently unaware of each other's presence in London to begin with, but once they met up seem to have enjoyed themselves, professionally at least. Pissarro wrote later: 'Monet and I were very enthusiastic over the London landscapes. Monet worked in the parks, whilst I, living at Lower Norwood, at that time a charming suburb, studied the effects of fog, snow and springtime. We worked from Nature, and later on Monet painted in London some superb studies of mist. We also visited the museums. ...' Pissarro stayed for the most part, for his subjects, close to his niche in Upper Norwood: the well-known painting of the steam locomotive coming round the bend is of Lordship Lane Station near by (p. 102) – a remarkable contrast, in its modest sobriety, to Turner's apocalyptic vision of the railway in *Rain, Steam and Speed* (which Pissarro certainly knew later if not already). He made more extensive forays to Dulwich College and the Crystal Palace (perhaps with Daubigny, who also drew the Palace), which produced two of the most delightful paintings of his first London stay (p. 102). It was the new London suburbs that attracted his attention: Dulwich and the Crystal Palace on its new site were both relatively new, and neither are presented as monuments but as part of the fabric of passing life and weather. As Alan Bowness has remarked: 'At its best, Pissarro's art is a paradigm of the realist's earthly paradise – a society in which people go about their tasks contented and in a responsive environment. The new suburb of Norwood, like the small Seine Valley town of Pontoise, or the village of Louveciennes, all take on for Pissarro an ideal aura, improbable though this may seem at the present day.' His images of London were from a new angle of vision, and suburban dwellers now might well find themselves looking on them as ideal landscapes

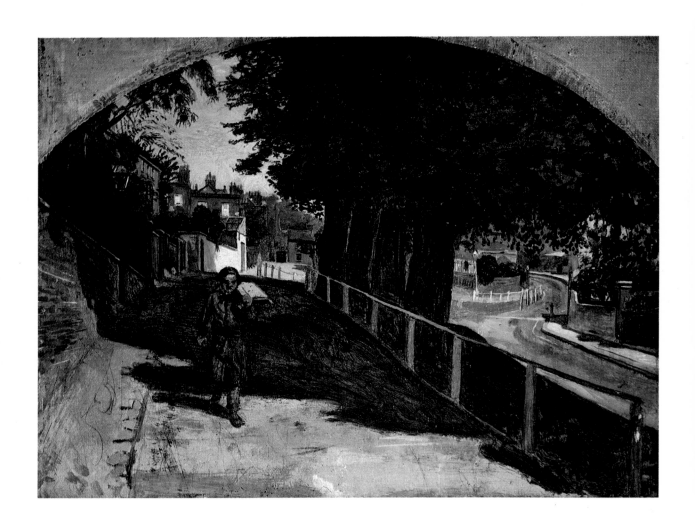

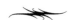

ABOVE **Ford Madox Brown**, *Heath Street, Hampstead*,
1852–5. This small oil sketch of Heath Street, done on
the spot, was a preliminary study for Madox Brown's
famous painting *Work*, inspired by seeing a group of
navvies excavating the street. (c.f. Atkinson Grimshaw's
painting of Heath Street on p. 116.)

RIGHT **Sidney Starr**, *A City Atlas*, 1888–9. Starr was a
follower of Whistler until Sickert introduced him, in
1888, to the work of Degas, whose influence can be seen
in this view from the top of a city atlas (a type of
omnibus) travelling through St John's Wood.

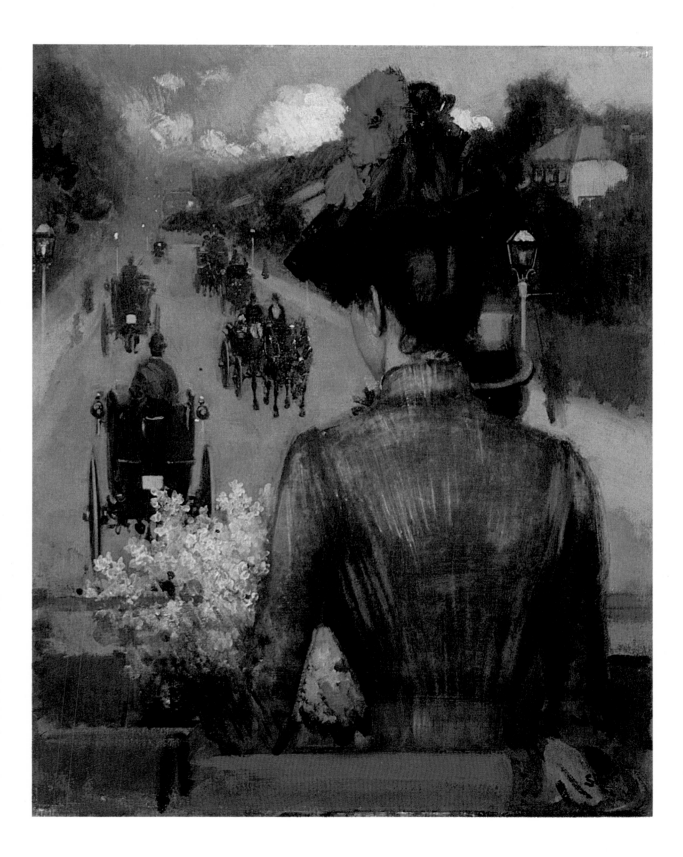

LEFT **Camille Pissarro**, *Lordship Lane Station, Lower Norwood*, 1871. For many years this painting was thought to be of Penge Station but it has recently been identified as Lordship Lane Station (now closed) which is on the London, Chatham and Dover line.

RIGHT **Camille Pissarro**, *The Crystal Palace, London*, 1871. The Crystal Palace – 900,000 square feet of glass designed by Sir Joseph Paxton – was erected in Hyde Park to house the Great Exhibition of 1851. Later it was moved to Sydenham where it burnt to the ground in 1936.

BELOW **Claude Monet**, *Green Park*, 1870–1. Monet's view of Green Park looks towards Hyde Park Corner, with Piccadilly on the right, and the old Wellington equestrian statue towering in the distance.

almost in the manner in which the English aristocrats of the eighteenth century nostalgically viewed the landscapes of the Roman Campagna by Claude. I suspect Constable would have been delighted by Pissarro's Crystal Palace or his Dulwich.

Monet was based more centrally at Kensington, and there he could walk the parks. Of Hyde Park and Green Park he left two paintings. Desultory figures in dark dress stray on the expanse of grass and among the trees. In *Hyde Park* (looking north-west to Lancaster Gate) the chimneys of Bayswater provide a fret to the veiled sky; colour and light are muted. Monet announces the possibilities of painting in a lack of English light, the haze and dimness that no English painter had yet discovered; many indeed had fled to the clarity of Italy to avoid it. In the best-known of his 1870-1 paintings (p. 2), the specific theme from which he was to distil a hundred variations thirty years later, is stated: the river, its bridges and Barry's Houses of Parliament (in 1870 still almost brand-new, for the clock tower with Big Ben, and the pinnacles of Victoria Tower, were only ten years old). But in this view the material components of that theme are already dissolving in a luminous mist: the necessary scaffolding for his composition is established by the geometry of the wooden jetty in the foreground, and the silhouettes of the two tugs; the bridge and the towers of Westminster Palace are almost insubstantial. The firm rectangular grid of the new bridges (Cannon Street, Charing Cross – modern iron structures for the approaches to railway termini) seems to have appealed to the Impressionists, no doubt because of their forthright clarity, but also because of compositional possibilities inspired by the Japanese prints that had become popular in the 1860s.

Monet's fascination with London lay dormant after this painting for decades. Pissarro's was reactivated only in the 1890s after his son Lucien had settled in London. The French however were not absent. Sisley was in England in 1874. Although he painted mainly the environs, registering marvels in sparkling light and colour at Hampton Court, he did at least once accept the challenge of the Thames in central London: a view (p. 97) from the south bank, looking over the rectangular grid of Cannon Street railway bridge to the silhouetted skyline of the City and the dome of St Paul's. Rather ironically, Sisley being of British stock, the exaggeration of the rising slope and the dome suggests London almost in Parisian terms, as if St Paul's were a near relative of the Sacré Coeur. Stylistically, in its effect of vibrant instantaneity, it is purely impressionist, and painted in the year of the famous first exhibition in Paris when the term 'Impressionism' was coined.

There were other visitors not so closely associated with revolutionary artistic

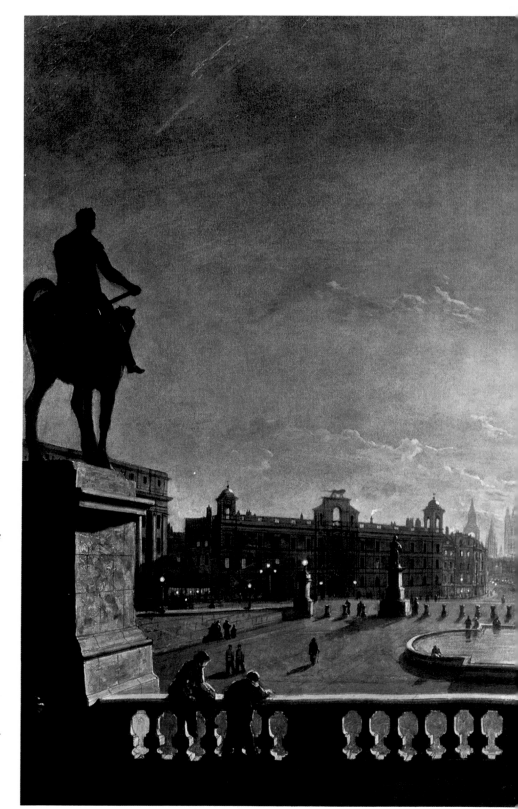

Henry Pether,
Northumberland House and Whitehall from the North Side of Trafalgar Square, by Moonlight, c. 1861–7. Trafalgar Square was formed in the 1820s on the site of King's Mews, Charing Cross, as part of Nash's proposed improvements to link Pall Mall to St Martin's Lane following the completion of Regent Street. The northern terrace, designed by Sir Charles Barry, was not completed until about 1850. Northumberland House, built for the Earl of Northampton between 1605 and 1612, was demolished in 1874.

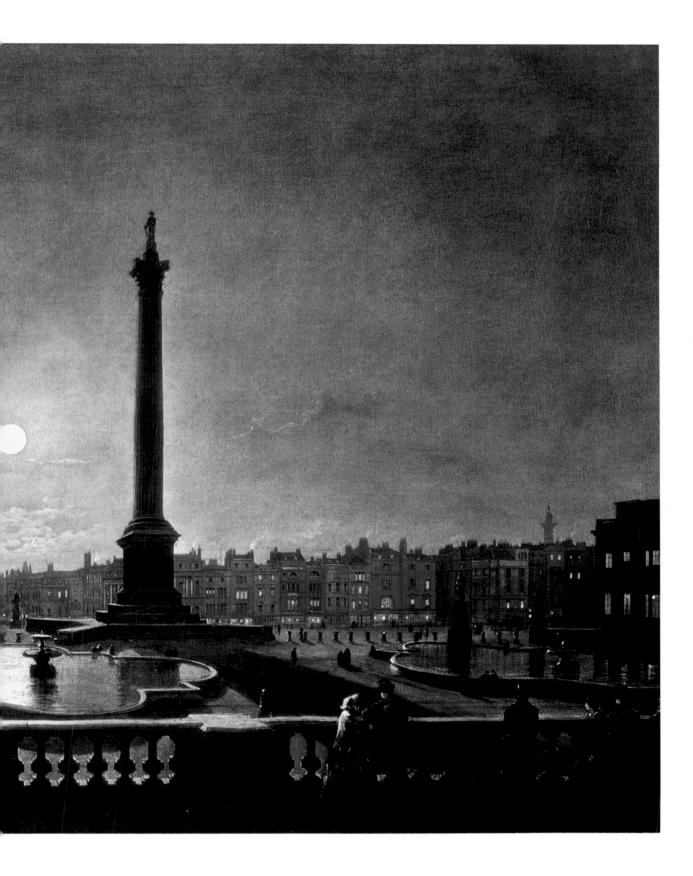

movements. A very notable one, for one aspect of London, was James Tissot. He probably made one or two visits before settling in London in 1871: having participated actively in the Commune, he escaped to London to avoid prosecution and remained based there for a decade. An enduring friend of Degas, from whom he declined an invitation to participate in the Impressionist exhibition of 1874, he was nevertheless rooted in a more academic tradition, with undeviating emphasis on polish of finish and meticulous attention to detail, both remote from Impressionist interests. Yet he was also close to Whistler, apparently all through the 1870s, and his early London pictures are probably influenced by Whistler's earlier, realistic, dockyard paintings. He was not though a landscape or townscape painter, but basically a genre artist, of figures in a setting, conversation pieces. Anecdote is never far away from his subjects, and one of his great strengths was his ability to suggest an eerie psychological unease. There is a whole sequence of paintings of a woman, usually identified as his mistress Mrs Newton, in the garden of the house in St John's Wood where they lived, that have a sunlit yet airless tension, as though of a *paradis maudit* – a paradise already doomed. Ruskin disapproved of Tissot's painting, dubbing him in 1877 a practitioner in 'mere coloured photographs of

FAR LEFT **James Tissot**, *London Visitors*, 1874. The scene is the portico of the National Gallery, with St Martin-in-the-Fields beyond. The columns of the portico came from the demolished Carlton House, an economy measure which the architect of the National Gallery, William Wilkins, was obliged to accept.

LEFT **James Tissot**, *Going to the City*, 1879. Tissot's scenes of fashionable London life enjoyed great success.

RIGHT **Gustave Doré**, *Une Rue Occupée*, c. 1869. A preliminary drawing, for *London: A Pilgrimage*, of warehousing in the narrow, crowded streets around the London docks.

BELOW **Gustave Doré**, *Over London – By Rail* from *London: A Pilgrimage*, 1872. '... where gigantic brick viaducts bestride the streets of mean houses and the engines shower soot over tiny backyards hung with washing'.

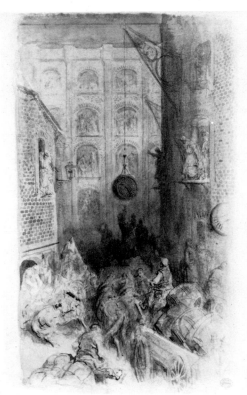

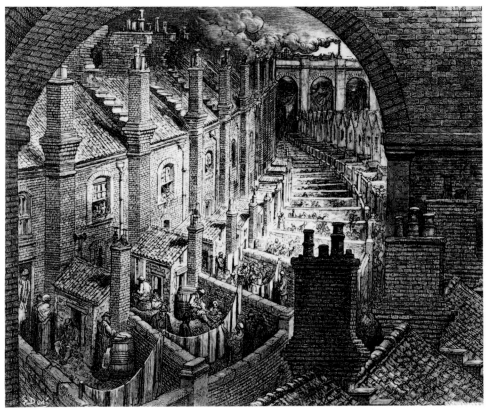

vulgar society', but his very precision now lends to his work an enduring fascination, not least when the setting for his figures is a specific London corner. In his *London Visitors* (1874), he records a close-up of what is still one of London's most delectable views, through the portico of the National Gallery to the spire of St Martin-in-the-Fields, unchanged after over a hundred years, though the blue-coated, yellow-stockinged schoolboys from Christ's Hospital are rarely seen nowadays (p. 106). Tissot's London is a prosperous city of prosperous people, a city of leisure and a not disagreeable ennui. The allure and confidence of the high Victorian financial world of the City is nowhere better evoked than in *Going to the City* (1879): the top-hatted senior citizen at ease with his morning paper in his hansom, trotting sedately along the south flank of St Paul's (p. 106). It is an image of one face of London that offers startling contrast with some others recorded by another of Tissot's compatriots. Ruskin, when condemning Tissot, did nevertheless detect a latent talent that would make Tissot capable, he thought, if he were to 'obey his graver thoughts, of doing much that would, with real benefit, occupy the attention of that part of the French and British public whose fancy is at present caught only by Gustave Doré.'

Doré, roving London with his collaborator (librettist almost) Blanchard Jerrold, had done most of the work for their *London: A Pilgrimage* in 1869, though the book did not appear till 1872. Although Jerrold wrote that their search was always for 'the picturesque – the imaginative side of the great city's life and movement', the picturesque is very far indeed from that of Malton's *Picturesque Tour through London and Westminster* eighty years earlier, or even from Rowlandson's view. Cruikshank, of whom Jerrold was a great admirer, came closer, but Doré's view is overwhelmingly in key with that of the late Dickens and that of Henry Mayhew's *London Labour and the London Poor* (1861). Evidently an agreeable and sociable creature, Doré had written enthusiastically on first visiting London of its gastronomic opportunity – *'cette Babylone des lunchs'* – but once involved in exploration of the city, his pencil revealed something very different, answering rather Carlyle's vision of the 'gleam of the great Babylon, affronting the peaceful skies'. Although Jerrold's text emphasizes the interdependence within London's polity of the various classes, Doré's rendering of the well-to-do (in the context of accounts of the fashionable

PREVIOUS PAGES **John O'Connor**, *St Pancras Hotel and Station from Pentonville Road: Sunset*, 1884.

world on parade in Hyde Park, or at the Derby, or – two whole chapters! – at the Boat Race) lacks substance and conviction: it is always more difficult to depict the good than the bad. In contrast, his vision of the labouring classes, of the destitute, could serve as illustrations to levels of Dante's *Inferno*. They are the suffering damned, set in surroundings that are the physical extension of their deprivation. They teem like ants, or sometimes like maggots. It is of course a melodramatic view: for a matter-of-fact account, in the end even more impressive in its prosaic sobriety, the photographs of street life by John Thomson and Adolphe Smith, taken a little later in the mid-1870s, offer a corrective contrast. But Doré's nightmares have a formidable intensity, whether focused on the prisoners trudging their round in the exercise yard of Newgate (the print on which Van Gogh based a famous painting), or the jam-packed traffic of horses, carts and human beings engulfing London Bridge or Ludgate Hill, or the bridge-spanned canyons of the wharf-side warehouses. The last – especially in some of the drawings (p. 107), before they hardened into engraving – are like Piranesi, but based on fact not on a haunted fantasy. As a literal recorder, Doré is not always reliable on detail: he drew from memory or rough *aide-mémoires* made on the spot, providing, for example, London Bridge with pointed rather than round arches. But the conviction of actuality is most formidable in the famous print – indeed like a segment of circle of the *Inferno* – of *Over London – By Rail* (p. 107). On this London the sun never shone.

It seemed to need an immigrant's fresh eye, for whom London was a phenomenon of astounding uniqueness, to grasp the opportunities it offered. London failed, for example, to quicken the pulse of the Pre-Raphaelites. Certainly Ford Madox Brown attempted a pictorial synthesis of a society at work on various social levels in his *Work*, a modern allegory fascinating in its detail if incoherent as a whole. The setting is suburban, the glimpse of Hampstead High Street in a preliminary study (p. 100) poignant for those who know what that hill has become in the flood of motor traffic, cafés and boutiques, but none of his contemporaries grappled with central London. There are however some glimpses, by more conventional painters, that catch something special and idiosyncratic. Henry Pether, one amongst a dynasty of painting Pethers and a specialist in moonlight views, recorded Trafalgar Square in about the mid-1860s (pp 104–5). The moon presides over an almost empty square: silence and melancholy are almost palpable, the few figures private in their contemplation. Nelson's Column lifts stark against the sky, old Northumberland House still stands, and far away at the end of Whitehall the towers of Westminster are spectral. The scene is very void – almost no traffic, no street furniture – an arena for some eerie surreal activity that de Chirico might

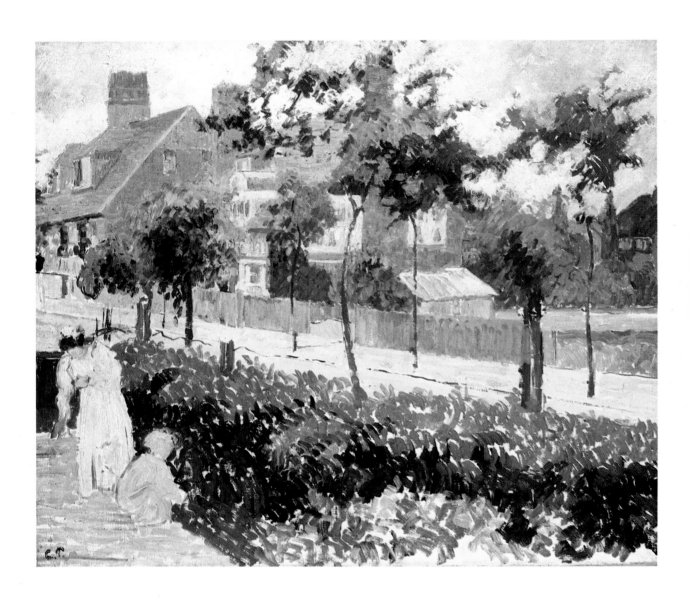

Camille Pissarro, *Bedford Park, Bath Road, London*, 1897.
Pissarro visited London for the last time in the summer of
1897 when his son Lucien, who was living at 62 Bath
Road, Bedford Park, in West London, fell seriously ill.

PAGES 114–15 **Claude Monet**, *Waterloo Bridge, Grey
Day*, 1903. When Monet exhibited thirty-seven of his
London paintings at the Durand-Ruel Gallery in Paris in
1904, eighteen of them – the largest group – were of
Waterloo Bridge, seen from above as Monet viewed it
from a balcony of the Savoy Hotel.

have provoked, if not Pether. Or there are the apotheoses summoned up by John O'Connor, who started as a scene painter and never lost his taste for the exultantly flamboyant. His masterpiece was a view from a roof-top in the Pentonville Road painted in 1884 (pp. 108–9). The foreground is registered in photographic detail – the pedestrians, the horse-drawn trams, the small neighbourhood shops, the jumbled roof-line with smoking chimneys – but beyond soar the pinnacles of the frontispiece to St Pancras Station, the St Pancras Hotel (1868–74) by Sir George Gilbert Scott. The building floats in the mist as if an enchanted castle; above it, the polychrome curdled sky. Here is the real Victorian romance: instead of a cathedral, a Gothic railway-station-cum-hotel in apotheosis, as if sanctuary not only for travelling bodies but for errant souls. This was an effect of hand-painted art which the photograph could not yet attain, though photography, and engraving based on photography (or designed to seem as accurate as photography), would soon begin to fulfil the needs of topography in periodicals as in books. The most faithful-seeming, minutely detailed of academic painters could still convey sensations beyond those in any photograph: so Atkinson Grimshaw, master of rain-wet streets in wind-scoured dusks, raises goose-flesh on the observer and an instinctive feeling that one should turn up the collar of one's raincoat (p. 116).

The supreme tribute to the most pervasive element of Victorian London – fog – was yet to be paid. By the 1890s, Whistler had virtually ceased from painting river-side nocturnes, though in the 1880s he was working on some of his most colourful studies of Chelsea houses. His followers, like the boatman's sons Henry and Walter Greaves, produced some admirable exercises in his style, but it was Monet who was to capture finally the atmospherics of the London Thames. Pissarro, on his visits to London in the 1890s to stay with his son Lucien, though he painted some more central views, remained largely faithful to his suburban studies: quiet and charming views at Kew; the tranquil road in the new model suburb of Bedford Park seen from Lucien's front garden. Monet however had been nurturing the concept of a whole series on London themes since the 1880s.

The sequence of these paintings is reasonably clear, if not provable. In 1871 Monet had been moved by the light, diffused already by London's mist, breaking again on the waters of the Thames: the solid stone of the new Westminster Palace towers becomes insubstantial, magical wraiths of a dream no doubt, but for Monet more realistically a crucial upright on which to stabilize the shifting horizontals of his landscape composition (p. 2). That was in 1871. In the 1880s, his acquaintance with Whistler developed into something closer: in the summer of 1887 he was in London briefly, and though he did not paint, came

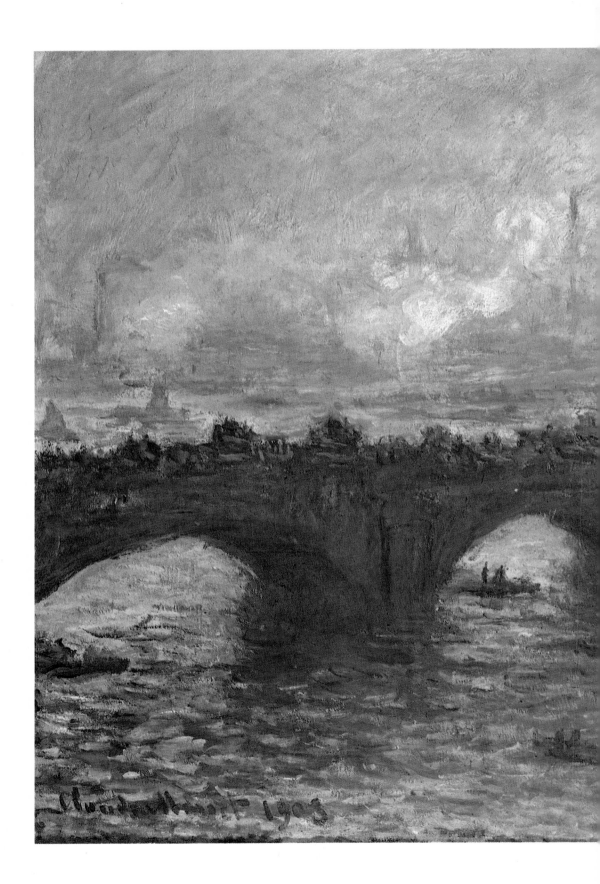

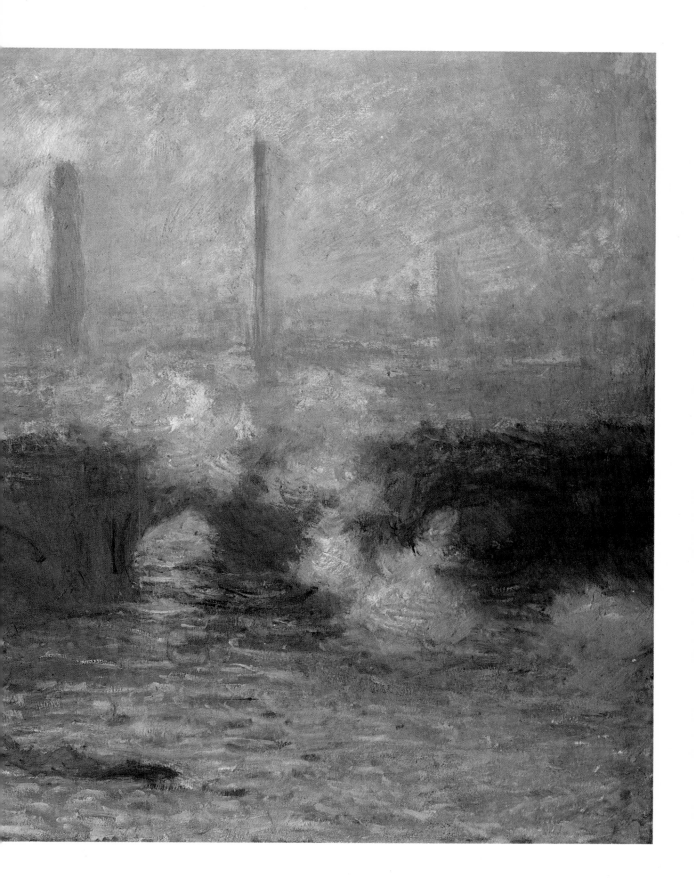

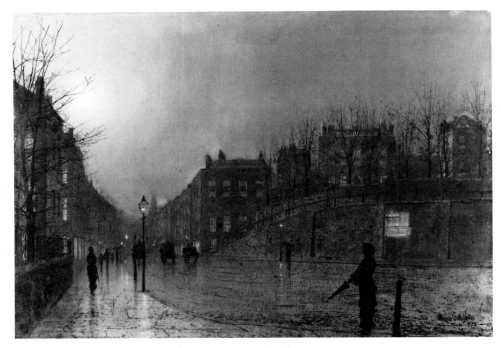

Atkinson Grimshaw, *View of Heath Street by Night*, 1882.
A damp and blustery air on the upland streets of built-up
Hampstead, painted by the High Victorian master of
lamp-lit gleaming dusks.

back 'enchanted with London and likewise with Whistler'. A month or so later
he was writing of his intention of returning to London to paint 'some effects of
fog on the Thames'. When at last, over a decade later, he moved decisively to
turn his intention into reality, he pitched tent in the upper floors of the Savoy
Hotel (which, unlike in 1871, he was now well able to afford) in visits spread
over three years, from 1899 to 1901. From a balcony there, in tenacious
concentration, he strove to trap the ephemeral moods of Thames light on his
canvas. He had three themes: first, probably, the welcome engineer's rigour of
the iron railway bridge to Charing Cross; then the superb arching rhythms of
Sir John Rennie's monumental stone Waterloo Bridge (pp. 114–15); and then,
probably on his last visit in 1901, now from an eyrie somewhere high in St
Thomas's Hospital on the south bank, back again to the subject started in
1871, the towers of Barry's Palace of Westminster, but seen now in the fretted
silhouette of the river-side elevation (pp. 118–19).

Later, reminiscing on his eightieth birthday in 1920 about this exercise,
Monet remembered having 'up to a hundred canvases on the go – for one single
subject'. His friends, the great statesman Georges Clemenceau, and his

biographer Gustave Geffroy, watched over his shoulder at the Savoy in 1900 as he 'accumulated the touches' on a canvas, then stopping: 'The sun's gone.' Geffroy diagnosed 'an abyss, whence emanated a faint rumbling . . . everything was about to fade away, to disappear in colourless obscurity'. But then Monet: 'The sun's back again.' His companions, perhaps borrowing Monet's eyes, saw 'little by little, things answering to a gleam of light, and it was delicious to see, feebly lit by an invisible sun, as if by a stellar nightlight, that majestic view yielding up its secrets'. Shuffling his canvases (mostly of a uniform size) as the light shifted, Monet matched the ephemeral moods of mist. His titles often indicate location and atmosphere: *Londres, le Pont de Waterloo: effet de soleil; Londres, le Parlement: trouée de soleil dans le brouillard.* But ultimately it is London controlled by his imagination.

Monet worked on these paintings long after he had returned to Paris, very conscious of them as a series. The silhouette of the too solid substance of Westminster changes shape according to the mood: now exaggerated in height, or modulated in its proportions; now looming like a dark Gothic ruin; now dissolving in luminous mist (*'trouée de soleil dans le brouillard'*). It was as a sequence, a set of variations, that thirty-seven of them were first shown in Paris in 1904. The catalogue had an introduction by Octave Mirbeau which is a classic of the peculiarly French rhetoric of exposition, a verbal panegyric of the atmospheric drama of Thames weather, untranslatable, alas, into plodding English (the paradox of London with its *'haleines épaisses, de soies encrassées, et avec toutes ses émanations de charbon'*, that nevertheless can manage to spout *'de cette atmosphère empyreumatique d'aussi splendides féeries de lumière'*). Monet, said Mirbeau, 'has seen London, has expressed London in its very essence, in its character, in its light'. He goes too far, of course. There are almost as many essential Londons as there are essential Londoners, but nevertheless Monet's vision is of a mysterious grandeur, and Mirbeau may well be forgiven for his enthusiasm: 'that prodigious city, made for painters, but that no painters until Monet had the wit to see; they only saw and expressed the *mince accident pittoresque, l'anecdote étriquée,* but never the ensemble, never the *fuligineuse* soul, magnificent, formidable, which now at last before us stands in its reality'. Yet it is only one man's view. The physique of London was for Monet, in the end, only a web on which the shifting atmospherics of Thames mist and fog could register; it was light fragmenting on the particles of mist and breaking on the waters that in turn break the reflections of stone and iron, that Monet painted. That he had in mind an apocalyptic vision of the centre of a great Empire, the seat of its legislature, dissolving in the crucible of his vision, like the cloud-capped towers in Prospero's prophecy, is extremely unlikely.

ABOVE **André Dérain**, *The Houses of Parliament*, 1905–6. This painting was probably executed during Dérain's first visit to London in 1905. He visited the city many times afterwards, realizing there some of his most brilliant work both in painting and stage design.

RIGHT **Claude Monet**, *The Houses of Parliament*, 1903. Reminiscing in 1919–20, Monet said: 'I love London so much, but ... only in winter. ... It is a mass, an ensemble, and it is so simple. But above all in London I love the fog. ... It is the fog that gives it its magnificent amplitude; its regular and massive blocks become grandiose in that mysterious mantle. ... How could the English painters of the nineteenth century have painted the houses brick by brick? Those people painted bricks they did not see, that they could not see!'

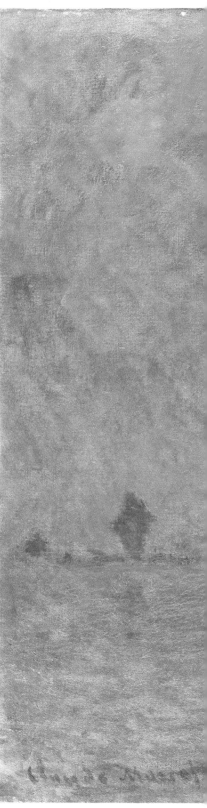

THE TWENTIETH CENTURY

THE MOODIEST, MOST HAUNTING VISUAL POETRY that has ever been spun out of London was Monet's – those melting variations on the Thames and Westminster above all. We have not seen the last of this painter who came to London most avidly at the turn of the century, but who was to turn again to a London subject before his death in 1926. He was far from being the last of that formidable band of temporary immigrants who paused from time to time to observe London and discover in her so many different aspects, some of which native Londoners had not dreamed existed until they were pointed out.

The most startling views of all are no doubt those banged on to canvas by Dérain, visiting when his temper was in the full effulgence of Fauvism (p. 118). In fact Dérain was excited by the subject to which most of the better and the great painters who have tried to capture essential London have succumbed: the Thames and its banks. In comparison with him however the meditations of Monet may seem almost effete. As if by some built-in distilling apparatus in the eye, Dérain concentrated colour that presumably existed in some muted form in the constituent elements of the scene before him, and used it pure to create a vision of London that never was nor ever shall be, but one that can produce a marvellous amazement in the cautious eye of the native Londoner, making him wish for a sudden explosion of sun to gild and fire his city with such tropic splendour. And long after Dérain the French still came, even if Matisse, here on his honeymoon in 1898, he had other preoccupations; nor did Picasso take advantage of his brief sorties across the Channel to paint the London roofscape as early on, in his migration to Paris, he had painted the chimney-pots of Paris. Dufy, in the Thirties, was the most remarkable and his version of coronation junketings in London and other goings-on are like a champagne soufflé of London *en fête*.

But there were other views, tempered by upbringings in other cultures. One of the great masters of German Expressionism, the Viennese Oskar Kokoschka, returned again and again. Indeed, in gratitude for sanctuary in London during the Second World War, Kokoschka became rather improbably a naturalized British citizen, even though British patronage was slow to welcome his art. Even more improbably, once Britain had reluctantly acknowledged his stature, it did so by making him a Commander of the British Empire, rather than by

Raoul Dufy, *The Coronation of King George VI*, 1937. Dufy visited England for the second time in 1937 when he painted this gaily-coloured watercolour of the coronation of George VI. He was particularly attracted by such royal ceremonial which offered his painter's eye a feast of form and colour.

showing an eager wish to acquire his remarkable visions of London. These date from 1925–6 to 1970. They are in effect the latest, and perhaps the last, of the great variations on the panoramic theme. As if poised half-way up the sky to heaven, Kokoschka surveyed the river as the expression of London. He went further than Whistler who claimed only Chelsea as his personal property. 'During the months I spent in London,' Kokoschka wrote of his first visit in 1925–6, 'I painted eleven pictures in all, mostly of the Thames … My Thames. … These were still the days when the wind did not blow, as it did in Vienna, from the Russian steppes, but from all points of the compass at once.' He was still at it forty years later, in 1967: 'I tried again and again to capture the Thames in a painting, the artery of life flowing from century to century, the river beside which multitudes gathered to form a community with a style of life all its own, bringing the most divers races together in a way that can be paralleled only perhaps in the ancient states of Asia, in China, or in the old Danubian Monarchy. …' Well, maybe. Kokoschka's prose takes off perhaps too easily, but in the more substantial medium of paint he saluted the Thames and London in visions which may at first sight seem apocalyptic beyond average experience, but which many viewers come to value as a just celebration of a loved one. Nor is he constrained by nostalgia: he painted old Waterloo Bridge, but then was able to salute its spare elegant replacement by Sir Giles Gilbert Scott with undiminished enthusiasm. Some critics find his later landscapes excessive. They are however generally stabilized by vertical strengths, often those of Barry's Houses of Parliament on which Monet and Pissarro also hung their pictures. So (looking, I wonder, from the Shell Mex Tower – a rare

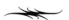

ABOVE **Malcolm Drummond**, *St James's Park*, 1912. This enchanting vision of St James's Park – of summer stilled and time suspended – was initially too far ahead of English taste, although Seurat's *La Grande Jatte*, the inspiration of which Drummond so happily acknowledges, was by then a quarter of a century old. A critic in 1912 noted that Drummond's painting had no 'refinement of colour or grace of drawing'.

RIGHT **Harold Gilman**, *A London Street in Snow*, 1917. The street in this painting is as yet unidentified, although thought to be somewhere in the Camden Town region.

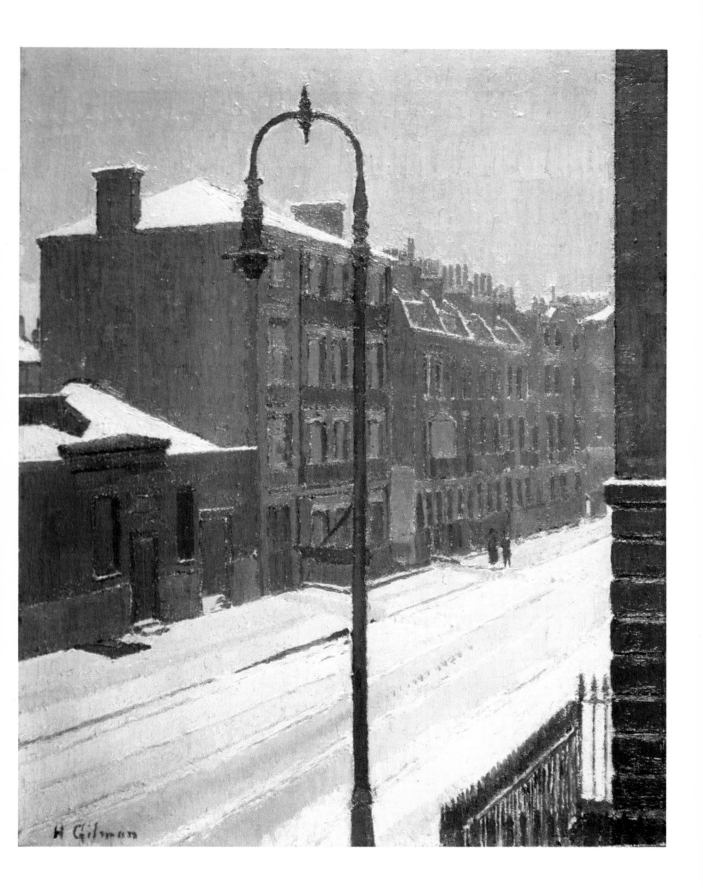

H Gilman

justification of that drear building), in a very late canvas of 1967, he recorded the Thames and Westminster under a sky now like an aerial battle, a dog-fight of blue and white exploding like flak (p. 151). The ruinous square tops of London postwar development are hardly visible, though he takes advantage of one of the better of them, the Vickers Tower, as one of his essential stabilizing verticals. London itself breaks up in a rage of colour, articulated by short sharp dashes, the river in flood in a vast diagonal down from left to right. Human life is absorbed, invisible, into the movement of the fabric of the city, the river, the sky. London is molten.

The emphatic bravura, the rhetoric, of Kokoschka is perhaps still difficult for English taste to accept. To the more characteristic British low-key understatement we shall come in a moment – but meanwhile a glance sideways at a rare Chinese view of London. Chiang Yee's *The Silent Traveller in London* attracted attention when it was published in 1938, illustrated by delicate wash drawings. These may have dated a little, evidence of not completely successful melding of the traditional Chinese vision with Western matter-of-fact, but the best are still charming, as is some of the commentary: 'I think the smoky, sooty surfaces of the walls of most London buildings do not bear close examination, but look beautiful behind the crystal-like rain screens, which give them lustre.' So Parliament Square under the slanting rain is seen again from above (but very unlike Kokoschka's view): the umbrellas like a bumper crop of mushrooms,

Oskar Kokoschka, *London, Large Thames View I*, 1926. After a brief first visit to England in 1925, Kokoschka returned at the beginning of 1926 and stayed for several months. During this period he painted at least ten pictures, fascinated especially by the majestic flow of the Thames. This Thames landscape shows the view up river from the Victoria Embankment.

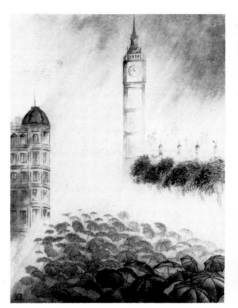

RIGHT **Chiang Yee**, *Umbrellas under Big Ben* for *The Silent Traveller in London*, 1938. Chiang Yee wrote of the London rain: 'Londoners may show no surprise as they are used to it, some may hate it relentlessly as it comes too often, and some may just take advantage of the wet to wash away the dust.'

FAR RIGHT **C.R.W. Nevinson**, *Wet Evening, Oxford Street*, 1919. Nevinson offers a more down-to-street version of rain-soaked London – in contrast to the oriental charm of Chiang Yee.

prolific, fragile and ephemeral. Big Ben's clock registers 11.20 a.m. The umbrellas are echoed by the cupolas on the corner of Parliament Street, and again on the Palace of Westminster. 'I could not see the faces but only the movement of umbrellas.'

The delicate charm of such Chinese whimsy would probably not have seemed entirely serious to the more exploratory native British artists who had begun to paint London fabric since the beginning of the century. They were following in the wake of Whistler and Sickert, but were stimulated by direct contact with the work of French Impressionists and Post-Impressionists. Sickert returned in 1905, from a seven-year sojourn abroad, based on Dieppe, and soon established himself in London with rooms in Mornington Crescent and a studio in Fitzroy Street. He was then forty-six years old, but still invested with something of the aura of *enfant terrible* that he had had earlier. Though he was older than the artists who collected, to begin with, about him, and very much the link-man between England and the new ideas fomenting in Paris, his younger colleagues mostly had their own direct contacts with France, whether from visits across the Channel or from the gradual infiltration of revolutionary work in shows in London – from notably a big Impressionist exhibition in 1905 to Roger Fry's epoch-making Post-Impressionist revelations in 1910 and 1912. These younger painters included Spencer Gore, Harold Gilman, Charles Ginner and Robert Bevan, and then C.R.W. Nevinson, as well as some now less well-known ones like Malcolm Drummond.

Sickert's own versions of London's exterior are not very numerous. Even though, introducing an exhibition of Impressionist works in London in 1889,

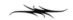

ABOVE **Algernon Newton**, *Paddington Basin*, 1925.
Paddington Basin, on the Regent's Canal, was Newton's
first big painting of a canal scene, a theme which was to
preoccupy him above all else for the next twenty-five
years.

LEFT **C.R.W.Nevinson**, *The Towpath, Camden Town, by
Night*, *c.* 1912. This curiously elegiac industrial idyll is
presumably an early work since it is free of the Fauvist
and Vorticist influences that galvanized Nevinson's style
in the First World War years.

he had pronounced that 'For those who live in the most wonderful and complex city in the world, the most fruitful course of study lies in a persistent effort to render the magic and the poetry which they daily see around them.' A follower of Whistler, Mortimer Mempes, wrote of the English Impressionists that 'there was another period when we used to travel all round London painting nature from the top of hansom cabs'. There is a delightful painting by Sidney Starr, another follower of Whistler who vanished from London to New York in 1892 following a scandal, of the view from the top of a horse-drawn bus known as an atlas (p. 101). It has obvious echoes of Degas, both in composition and technique, but was derived perhaps via Sickert, who noted that Starr's 'French training . . . was acquired mostly on the boulevards of St John's Wood'. Though Sickert himself considered repeatedly the surfaces of Dieppe, Venice, and indeed Bath, in London his main attention was focused on interiors with figures, besides his continuing love affair with music-halls and their audience. Glimpses of a rather Whistlerian London view, such as his etching (p. 130) of Maple Street (where Gilman had rooms for a time, close to Sickert's studio in Fitzroy Street), are fairly rare, although his account of the everyday limbo of Bayswater Underground Station (p. 133), ordered but also kindled with colour by his brush, is amongst my favourites of his paintings.

The grouping and regrouping of the younger artists, sometimes labelled as 'English Impressionists', took place in a relatively minute area of London. They were known typically as the Fitzroy Street Group, the Camden Town Group, or the Cumberland Market Group, and were associated with the 'inner outer' suburbs, though these now seem virtually of the inner city itself, and amongst them only sections north of Oxford Street, approximately between St John's Wood and Islington. The traditional 'set-piece' views, even those of the river, did not attract them, though Gilman once painted the river at Battersea, and made a few uncharacteristically bold and free drawings there (p. 130). Their interest lay in close-up shots in which the geometry of the buildings offered a secure structure on which to deploy, in their different ways, their patterns of broken colour and sensitively modelled tones. Their images nevertheless preserve a flavour which, while to the foreigner it might seem almost anonymously urban, for the addicted Londoner is essentially London – though now perhaps nostalgically so – in spite of the fact that London was not, for most of them, their favourite subject.

RIGHT **Claude Monet**, *Leicester Square by Night*, 1918? The lights of Leicester Square remembered by Monet from his visits of almost twenty years earlier.

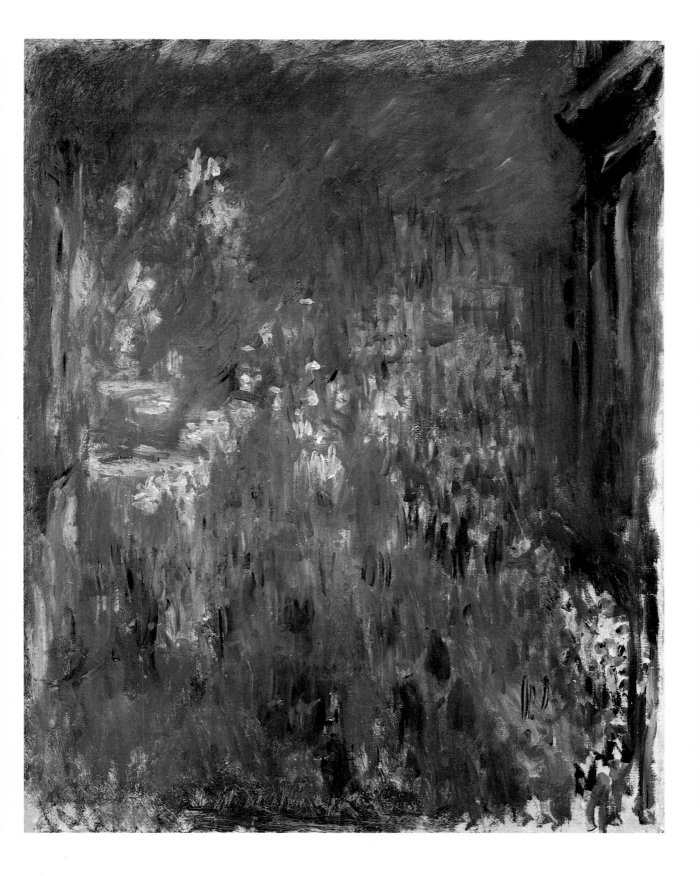

Thus Spencer Gore's charming and airy view from a Mornington Crescent window (1912) is essentially a happy haze of colour (he was at one point the closest to the Neo-Impressionists) foaming against the geometric slabs of the buildings. It is not a topographical account, although the liver-hued top of the Mornington Crescent Underground Station is gratefully welcomed into the composition. Nor was Harold Gilman a specialist in London views, preferring the country or, best of all, figure studies and figures in an interior, yet his *A London Street in Snow* (1917), is the most beautiful evocation of the city in the relatively rare mantle of snow (p. 123). Blue grey, mauve to lavender, handled with a most delicate mastery of tone – recalling perhaps the painter's admiration for Velasquez – build up a structure of the most satisfactorily resolved simplicity. The mood evoked is of that strange snow silence, muffling life within closed exteriors. Curtains will be drawn soon if not already done. Two little figures are alone on the pavement. Gilman of course was inside observing, I trust, from within the shelter of the closed window-frame (though working, as most if not all of them did, via a drawing from nature, not direct on to canvas as Monet did). Painting in the open is always a hazardous occupation in the English climate, and most of the London views of this group suggest that

ABOVE **Harold Gilman**, *Battersea Bridge*. Although the drawing is so titled, the bridge looks very like Hammersmith Bridge.

RIGHT **Walter Sickert**, *Maple Street*, c. 1920.

OPPOSITE ABOVE **Spencer Gore**, *Mornington Crescent*, 1912.

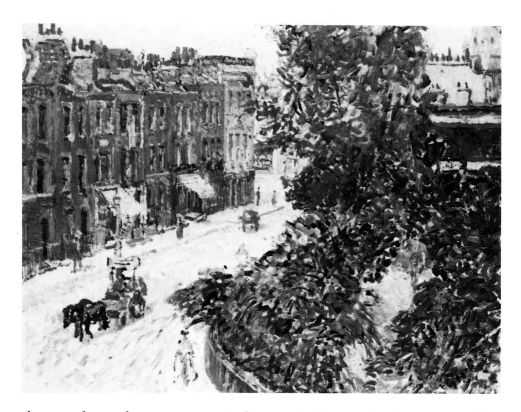

they are drawn from an upper window overlooking a street or square, often taking full advantage of slanting diagonal recessions, as so brilliantly in Gilman's picture.

Robert Bevan divided his attention between the countryside, horses and London. Even in his London paintings he managed often to feature horses prominently, whether in the streets or at Tattersall's horse and carriage market. He too seems to take up stance at an upper window, whether surveying the movement of traffic at Swiss Cottage, or the calmer reaches of the broad avenues of St John's Wood (p. 134): pale placid villas of a genteel classic reticence set behind the boscage of their front gardens. The shrubberies and trees assume simplified silhouettes, inherited from Bevan's earlier days at Pont Aven where he had known Gauguin, but the atmospherics are memorably those of the leisurely life of middle-class suburbia. In Gilman's picture one can easily imagine the 'damp souls' of T.S. Eliot's housemaids 'sprouting despondently at area gates'; in Bevan's views of St John's Wood housemaids do appear, but as neat and spry no doubt as the rooms they tend in the villas whence they come.

Nevinson moved in a somewhat different ambiance, though like the others his contacts with Paris were close, perhaps most tellingly with Cubism and then with the Futurists. One of the outstanding paintings of his early years is set in

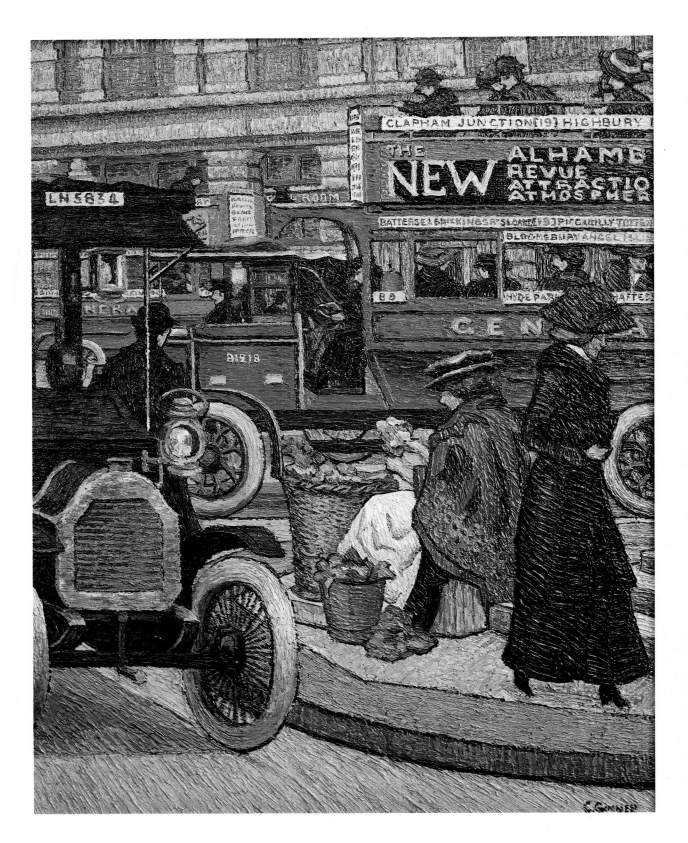

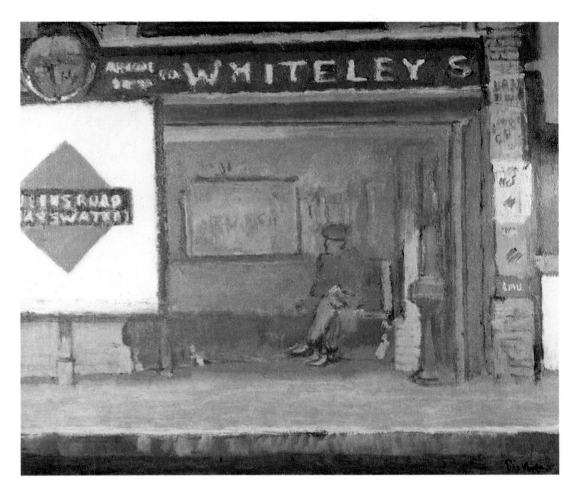

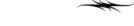

ABOVE **Walter Sickert**, *Queen's Road,
Bayswater, Station, c.* 1916. An early
investigation by an important artist into the
visual possibilities of the London
Underground system. The composition,
based on the interplay of rectangles of
colour, was perhaps influenced by Sickert's
awareness of Cubist developments across
the Channel.

RIGHT *London Underground Map,* 1964.
An almost Mondrian-like diagram based
on a drawing by Harry C.Beck of 1931.

LEFT **Charles Ginner**, *Piccadilly Circus,* 1912.
Early in his career Ginner chose to paint
crowded London street scenes using strong
colours and heavy outlines, in contrast to
his later years when he became a landscape
painter (c.f.p. 144).

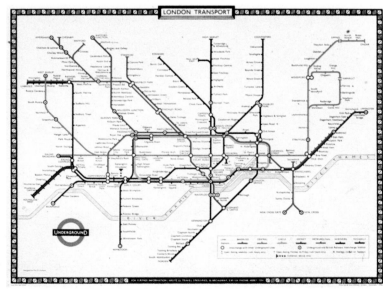

LONDON TRANSPORT

UNDERGROUND

Camden Town (p. 126), though the subject has overtones of industrialism (Nevinson painted other specifically industrial subjects). The handling of the muted blue to green paint that establishes the mood is in accord with Neo-Impressionist theory and technique, and there may indeed be echoes of Seurat and Signac, but the presence of the two lovers invests the whole with a particularly English lyricism, rather than sentimentalism. The urban proletariat is endowed here with an elegiac quality more generally found in late nineteenth-century pastoral studies of the peasantry. Nevinson's most remarkable pictures were certainly those, Futurist or Vorticist in style, of military subjects during the First World War, but traces of that style lingered on after that, applied perhaps with best effect to the sheer geometry of Manhattan, but also to some prismatic views of London, whether sunlit or rain-glinted (p. 125 and p. 135). Nevinson lived on till 1946.

Another artist of that generation, Charles Ginner, was more closely allied to begin with to Gilman. Gilman died young, in 1919, but Ginner continued through the interim between the two wars, and was a specialist in painting London. As an artist, he was probably the least original of those cited above, but he compels attention in our context by both the vigour and range of his views of London. He by no means confined himself to Camden Town but roved about, even lingering to trace in detail the lineaments of allotments in Bethnal Green, and not excluding the better-known, more monumental views that can reduce London to a series of platitudes. Like Monet he painted the towers of

Robert Bevan, *From the Artist's Window*, 1915–16. A view from Bevan's house in Adamson Road, St John's Wood, his London base from 1900 until his death in 1925.

C.R.W.Nevinson, *Amongst the Nerves of the World*, *c.* 1930. A view from a window high up in an office building in Fleet Street, looking east towards St Martin's Ludgate, St Paul's and Ludgate Hill. The buses are shown with the covered tops first introduced in 1925. Something of Nevinson's earlier Vorticist style – facetting and fragmenting – survives in this late painting of his.

Westminster, but seen from the Embankment Gardens in a weird transformation of English municipal horticulture into the terms of Van Gogh's spiralling flame-like cypresses at St Rémy or Arles. Van Gogh indeed had a lasting effect on Ginner's handling of paint. He painted thick, often outlining contours in ropes of colour that can look almost as if squeezed straight on from the tube. He painted Leicester Square and Oxford Street. His version of Piccadilly Circus (p. 132) makes a harsh metallic clash in contrast with Shepherd's view of its spare and elegant spaciousness only eighty years earlier (p. 80). The architecture is now all but invisible in the traffic. True, it has picturesque elements – the legendary flower-girls of the Circus, and the taxi that would now be a veteran car owner's prize treasure – but the motor car has arrived, and soon London, like all the great cities of the world, will stand knee-deep in the flood of mechanical vehicles, stranded stationary, slewed at the road's edges, or moving sluggishly in the centre of the streets when not congested into foetid jam. Ginner's view conveys a vivid impression of this new compression of life: the city is not observed, not observable, as once it was. If you raise your eyes above traffic level, if you stop to stand and stare, you may well be knocked over, or at least adjured unkindly to look where you are going.

Victor Pasmore, *The Quiet River: The Thames at Chiswick*, 1943–4. Pasmore settled in Chiswick in 1942, living first in Chiswick Mall and then Hammersmith Terrace, until he moved to Blackheath in 1947. This view, one of several variations on Thames themes which he painted during those years, is taken from close to his house in Chiswick Mall looking towards the small island known as Chiswick Eyot.

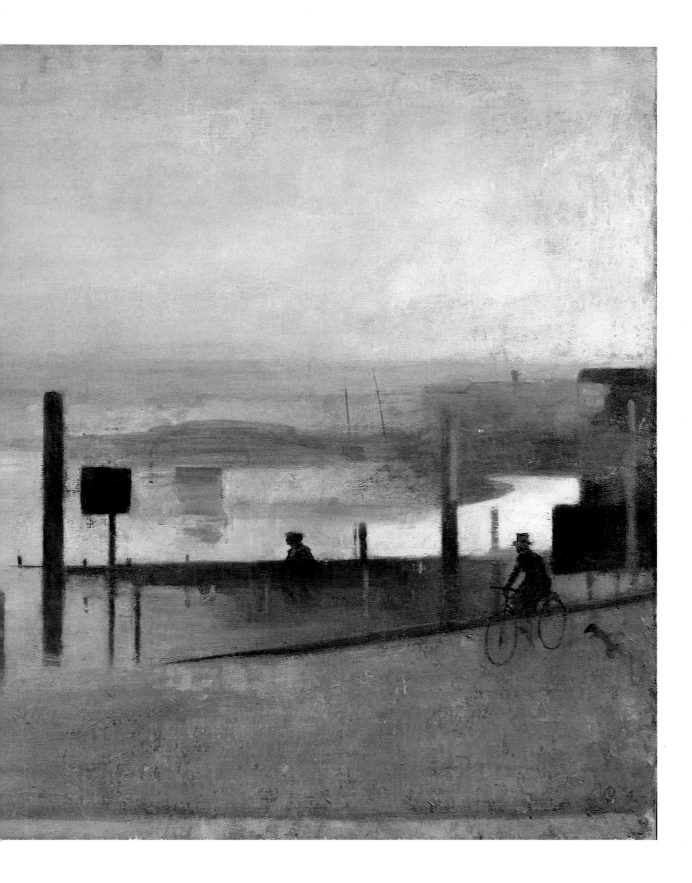

The impressions of London so far discussed in this chapter were provided by what was, in a modest and discreet way – leaving aside the more rigorous exercises of the Vorticists – the British avant-garde in the first quarter of the twentieth century. There were of course many artists, of high technical proficiency, working along more traditional lines and with a greater concern both for descriptive topography and for the usual (one is almost tempted to say, tourist) subjects. One aspect of London that British Neo-Impressionists, unlike Monet, did not follow, was the interpretation of London fog. Fog, as Oscar Wilde observed and as we have noted, was invented by artists, although in reality it had been clogging the throats and eyes of Londoners since the eighteenth century and earlier. Whistler, in fact, had not really dealt with London's fog but only with a version that was scarcely more than mist, nor, even, had Monet. The real pea-souper seemed to reduce lung capacity by about 95 per cent and made the eyes stream, limiting visibility to a yard or so – not a favourable distance for the artist, though maybe the American Abstract Expressionist Mark Rothko got near it in his later most profoundly sombre canvases. If as an artist you were inclined to have a gallant attempt, your colours would be almost by definition black and white, but mainly black. And there are drawings by late Victorian and Edwardian illustrators, followers of Charles Keene even if lacking his final trenchancy, that suggest vividly, if not the strangling quality of fog, then its mystery and in a sense its magic. The drawing from *Punch* in 1904 is a good example, but must stand as token for many more.

Such illustrators need reappraisal: some of them, while masters of literal accuracy, could, by their sensitivity to the most rewarding viewpoint convey something more than mere chronicling. Richard Howard Penton, a name not recorded with acclaim in the histories of modern art, was just such a one, but in the account he compiled of the City Companies' Halls as they were – before

LEFT *Fogged*, a drawing from *Punch*, 7 December 1904. The tradition of the great Victorian illustrators was carried on into the early twentieth century.

OPPOSITE RIGHT **R. Howard Penton**, *Skinners' Hall*, 1903.

OPPOSITE LEFT **Muirhead Bone**, *St Martin-in-the-Fields* from *London Echoing* by James Bone, 1948.

either war, before the motor car, if only just, and before the Blitz – he caught admirably the seclusion, the poetry of these narrow lanes sunk deep between the banks of the opulently modelled façades of commerce and finance, flowing discreetly and well, like unsoiled liquid gold. The most interesting of such illustrators and chroniclers of the changing face of London, from Edwardian times till after the Second World War, was Muirhead Bone, one of a school involved especially in the revival of etching. Amongst the others were Francis Dodd, Henry Rushbury and a number of accomplished artists following in the wake of Whistler and Whistler's brother-in-law Seymour Haden (with whom he was not on speaking terms). Muirhead Bone was the most striking, in his tireless energy and passion for detail, and because he illustrated *The London Perambulator* (1925) and *London Echoing* (1948), both by his brother, that brilliant journalist James Bone. One of the ways in which Muirhead Bone excelled sprang from his fascination for the city rebuilding, a delight in the intricate geometry of scaffolding, in the feel for the city in growth, in change and also in demolition. Another was his feeling for the drama of a great city in action. He loved the high-level view, looking steeply down as if on an ant-hill, but one that was spectacularly architected and, most notably, dramatically lit – as in his view down on St Martin-in-the-Fields towards the north-east corner of Trafalgar Square at night, lit at ground level by street lamps and shop illuminations. The technique is traditional enough – owing much, I guess, to French example, especially to that master recorder of Paris, Charles Meryon – but the view is new.

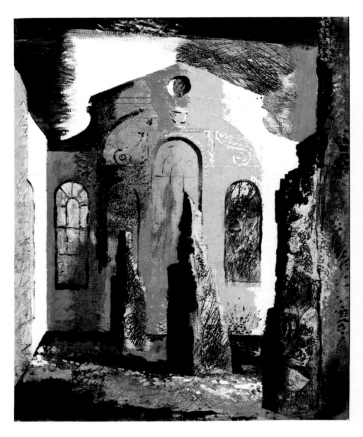

ABOVE **John Piper**, *Christ Church, Newgate Street, after its Destruction in 1940, 1941*. The painting shows the east end of the church as seen from the nave, after it had been gutted in a German fire raid. The shell of the church has remained a ruin, although the steeple has been re-erected.

RIGHT **Graham Sutherland**, *Devastation: an East End Street*, 1941. Sutherland's view of devastation in Silvertown in the East End shows the façades of houses bordering a deserted street, creating an effect of endless desolation.

David Jones, *Brockley Gardens, Summer*, 1925. A Celtic transcendence of a London suburban garden plot. Jones was born and raised in Brockley, in southeast London.

There were plenty of others too. Amongst the painters, in the academic tradition, there was Algernon Newton, whose first commissioned painting, in 1925, was a precisely detailed catalogue of the *Backs of Houses, Harley Street*, accounting for all accretions – chimneys, inserted mansard windows, extensions – that modern plumbing improvements lead to in most old London houses, down to individual bricks and slates itemized in an even, somewhat merciless light. In the same year he painted a bay in the London canal system, *Paddington Basin* on the Regent's Canal, and was dubbed the 'Regent's Canaletto' (p. 127). His staples were to be early to mid-Victorian classicizing stucco villas, and industrial buildings such as warehouses and tall chimneys preferably in a watery setting – but the still mirror-surface of canals, hardly ever the live currents of the river. The light strikes long and low, sometimes reflecting on the windows of the rectangular façades, but the windows are eyeless, and the appearance of a human being a great rarity anywhere in his vistas. His territory is often contiguous to Bevan's, especially the Paddington area (known as London's 'Little Venice'), though he worked elsewhere – Kentish Town and south of the Thames at Camberwell – but always playing variations on the same mood. The effect is entirely different from Bevan's: from its uninhabited stillness, in the staring but blind presence of those formidable

Unknown Artist, *London Underground Poster: Golders Green*, 1908. Frank Pick, who came to London as Chairman of the Underground Group of Companies in 1906, revolutionized the design of Underground posters, commissioning such artists as McKnight Kauffer, Graham Sutherland, Frank Brangwyn, Fred Taylor, Laura Knight and E.A. Cox. This poster extols the virtues of what were then the outer suburbs:

'Tis pleasant, through the loopholes of retreat,
To peep at such a world: to see the stir
Of the great Babel and not feel the crowd . . .'

houses, the atmosphere that accumulates as you watch is one that may be familiar to anyone who has entered an abandoned town that has been evacuated by its inhabitants in the face of impending and hostile occupation. If not invasion, dereliction impends. Newton's images, executed indeed in a traditional technique, are the most disturbing and literally surreal of any British painter of the period, although he was never associated with the Surrealist movement.

Though he lived on until 1968, Newton abandoned London subjects in about 1953. He had though many contemporaries content to record, with more or less efficiency, the London scene, and many more in the younger generation following on, but none with quite that electric tension that the best of Newton's work achieves. They are always more prosaic, or, in comparison with Newton, over-emphatic. Those who can achieve a genuine poetry are rare: one such is Christopher Hall, recording a placid backwater in Tolmers Square, St Pancras, in 1954 (p. 145). His painting has all the agreeable ennui of the doldrums of an urban afternoon, but the two children and the black cat endow it with a human hint of anecdote. With no sign of the postwar drab of the early Fifties, the painting is positively nostalgic for an earlier time.

The sheer vastness that London had achieved by the mid-twentieth century –

143

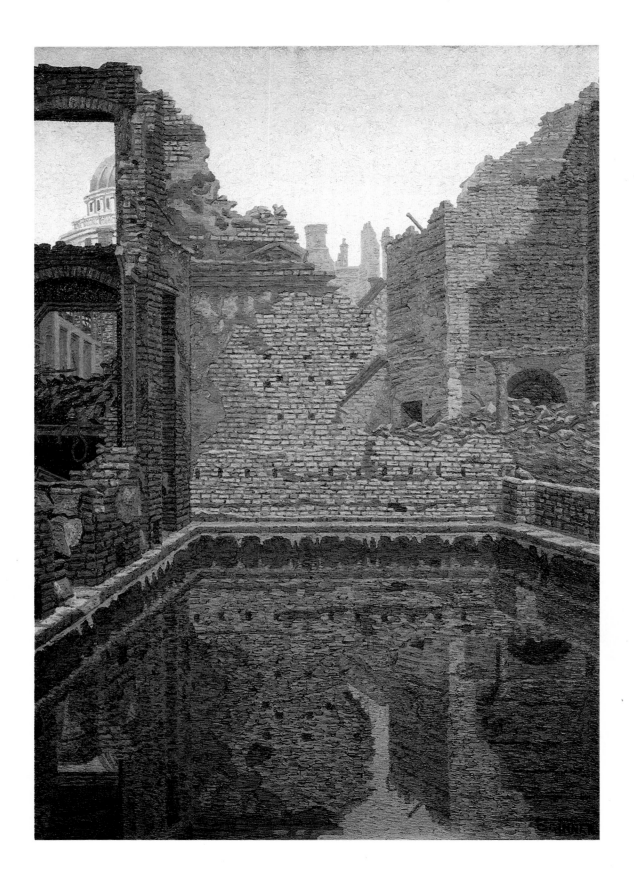

LEFT **Charles Ginner**, *Emergency Water-Storage Tank*, 1941–2. Open water-tanks, often created in the derelict basements of bombed-out houses, were used to provide reservoirs for the fire-fighting services, and were a common feature of London during the Second World War. Canaletto's famous *Stonemason's Yard*, in the National Gallery, London, is said to have been much in Ginner's mind when he painted this scene.

RIGHT **Christopher Hall**, *Tolmers Square, St Pancras*, 1954. Tolmers Square, to the north of the Euston Road, is now much dilapidated. The area on the left of the painting has been much developed, so that high-rise buildings now dominate the scene. The building on the right is the back of the Tolmers cinema.

its sprawl, the cancerous shapelessness of the apparently uncontrollable spread of the Great Wen – is a subject scarcely picturesque. In visual form London is best but depressingly summarized by a comparison of the contained, almost shapely, ink-blot expressed on a diagram to show the extent of London's built-up area in 1840 (though by then it was already grossly swollen from what it had been in 1740, let alone in 1640) with the vast octopus into which it had expanded by 1929. Within that tide individual villages might, and some did, retain a nucleus of individuality, standing clear amidst the flood, but the impression is of a relentless tide of low-terraced houses – embryonic slums – swamping the land out towards the more aerated outer suburbs. Uncontrollable. The clearest image of rational man's attempt to control at least a part looks below the surface, descrying in London's subterranean depths a most elegant clarity. The standard diagram of the Underground system (p. 133), that goes back to a drawing of 1931 by Harry C. Beck, is lucid, spare and almost criminally optimistic in the prospect it offers of joyous travellers switching effortlessly at junctions from train to train and speeding swiftly to their destinations. They do not. The diagram nevertheless is a thing of beauty and a joy, almost worthy of Mondrian, to behold, though more recent additions to the system – the Victoria and Jubilee lines – have somewhat congested it. In the Thirties London Transport sponsored some remarkable posters. It may be that the vistas of sylvan tranquillity some of them promised in the outer suburbs of

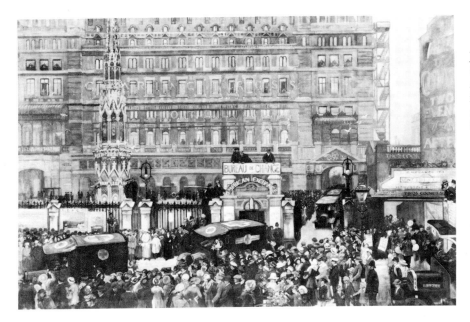

J.Hodgson Lobley, *Outside Charing Cross Station, July 1916*, 1919. Ambulances, bearing casualties from the Battle of the Somme, are shown leaving Charing Cross Station.

Metroland that London Transport was feverishly opening up, allied with the builder-developers, might be no less fallacious than the Underground diagram, but some of the designs that artists like McKnight Kauffer produced were artistically far superior to the average range achieved by the figurative artists of this period in easel paintings (p. 143).

In the twentieth century London suffered tribulations of a kind that England had not had to endure since 1066: physical assault on its very existence. In two wars there was actual invasion from the air when the Channel was proved finally to be no longer the invincible bastion that it had been for centuries. The appalling carnage of the First World War however took place in Flanders, far from London; in retrospect the damage to the city wrought from the air seems almost negligible, and the monsters responsible – the Zeppelins – as weirdly obsolete as dinosaurs. The first impression from Muirhead Bone's version of Piccadilly in 1915 is of carnival, of a crowd at a firework display (p. 148). The sinister implications of the searchlights fingering the night sky scarcely register, and the black-out at ground level is ridiculously inefficient (though throwing light upwards as Bone loved light to go). The First World War saw the establishment of a new and welcome category amongst the military: official war artists. Inevitably, the most vivid images of war came from their experiences abroad. Bone was one (indeed, the first), but they included Augustus John, William Orpen, Wyndham Lewis, Nevinson, Paul Nash, John Singer Sargent. Of these only Bone and Nevinson subsequently turned back to London subjects. Stanley Spencer, who served as an orderly in the R.A.M.C., was to produce one of the most moving of war memorials in the chapel at

146

Burghclere, but virtually ignored London (apart from some views from a niche at the Vale of Health on Hampstead Heath). Spencer of course was obsessed with tracing paradise elsewhere, with painstaking assiduity, in the village of Cookham. There are nevertheless a few memorable glimpses of London in the tension of war tucked away in the Imperial War Museum. For example, a canvas by the now obscure J. Hodgson Lobley of ambulances emerging from Charing Cross Station in July 1916, with their burden from the Western Front, seems more than merely able – a compelling illustration in the margins of those endless black-smudged columns of casualties that appeared daily in *The Times*, as war was brought home to Londoners. Amongst the English war-time views of London, there surface, startling and enigmatic, the three or four canvases Monet made of Leicester Square (p. 129), apparently indubitably so titled and dated 1918, but presumably dating back to twenty-year-old memories of London, or perhaps to photographs. (The celebrations in London for the relief of Mafeking in May 1900 might seem a possible source, but Monet had left the city in April of that year.) A spatter of light in green tree-tops under a night sky. It might be read as a celebration of armistice revelry; it can also be read as a variation in that endless exploration of colour, in which the major theme that preoccupied Monet's old age was provided by the water-lilies at Giverny.

In the Second World War, when the Blitz was unleashed from the summer of 1940 onwards, London became in contrast the centre of a major theatre of battle. Its fabric, through whole districts, was to be rent to jagged fragments, forlorn over rubble. Some of the most distinguished of the British artists who had been forging their styles through the Twenties and Thirties were now directed to the recording of this spectacle. Graham Sutherland in the shattered Silvertown area of the East End, confronted by streets in which the gaunt façades of modest terrace houses somehow still stood though the whole of the rest of their structure was destroyed, found 'they were great – surprisingly wide – perspectives of destruction seeming to recede into infinity and the windowless blocks were like sightless eyes' (p. 141). For John Piper air-raid damage provided, somewhat ironically, an ideal subject for a technique which he had been working out in 1938–9 for recording architectural picturesque (p. 140). The play of colour over line, of line over colour, reveals an elegiac incandescence of decay. Both Sutherland and Piper brought an already largely formed vocabulary of form and colour to these fresh challenges, and both found their equipment more than adequate to cope with them.

For Henry Moore the opportunity might have seemed less apt, and yet the famous Shelter Notebooks stand undiminished, even compared with his major sculptural achievements, and are perhaps the most humanly moving of any

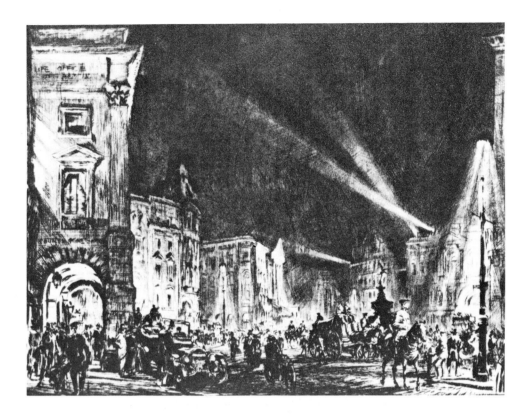

artist's testimony on London's ordeal in the havoc of the Blitz. The Notebooks include vivid drawings of desolation in London streets the morning after – a façade disintegrating in collapse, groups of figures standing congealed in the rubble of a bombed road, expressing in their motionless silence the usual query 'Where on earth do we start?' But the archetypal images which Moore created are those of the sleepers, huddled deep underground in the Tube stations that served as shelters. These figures – swathed, anonymous, shrouded even, in the womb-like protection of the tunnels arched over them – are enduring memorials of human survival. They have a grandeur, a universal immediacy, which perhaps persuaded a reluctant public to recognize, more than did the artist's sculptures, that here indeed was a genius, comprehensible and assertive for ordinary human aspirations.

None of these artists was very literally or recognizably topographical. Artists with a more precisely locatable topographical interest were of course active, the veteran Muirhead Bone amongst them. So too was the veteran Charles Ginner: still undefeated in his passion for recording London, he was moved to create one of his best paintings, delineating the hollow shells of ruined houses in the City, with part transformed into an emergency water-storage tank for the fire-fighters (p. 144). Beyond is St Paul's dome, inviolate. It may be that the most triumphant image of embattled London victorious was captured by the

LEFT **Muirhead Bone**,
Piccadilly Circus, 1915 from
London Echoing by James
Bone, 1948. Muirhead Bone
was the first official war artist
to be appointed in the First
World War.

RIGHT **David Bomberg**,
Evening in the City of London,
1944. Bomberg spent the
years of the Second World
War teaching in London,
but also producing several
drawings of the blitzed city.

BELOW **Henry Moore**,
*Group of Shelterers during an
Air Raid*, 1941. Moore was
appointed an official war
artist in 1940, and in
September began the Shelter
Drawings which were to be
his chief preoccupation
throughout 1941.

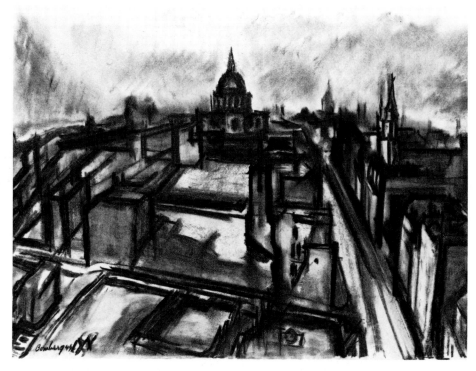

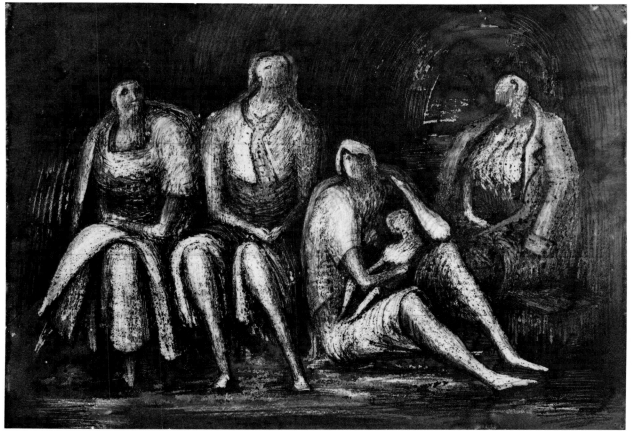

L.S.Lowry, *Deptford Power Station from Greenwich*, 1959. Lowry frequently visited London and made many paintings and drawings there, often combining views of the Thames with an industrial landscape, recording London (and Londoners) very much as a city and people of the north under a grey and indifferent sky.

photographer who caught, one night at the height of the Blitz, the dome of St Paul's miraculously intact, soaring above the welter of smoke and fire as the City about the cathedral burned. But for me the finest picture of all was drawn by another artist, a veteran too by now, the sometime Vorticist David Bomberg. In his *Evening in the City of London* (1944), the view is again over a gutted, flattened skeleton, the bombscape focusing on St Paul's (p. 149). However, drawn with stark, economic strength, as if still charred from fire, as it is, the impression is almost, perhaps optimistically, serene. All passion spent, but the idea of resurrection is not far off. The phoenix will arise from its ashes.

The phoenix that did arise however proved a malformed and awkward bird. Henry James, in one of his several meditations on the London of the late Victorian and Edwardian era, observed that 'the misfortune of London to the eye . . . is the want of elevation'. Over whole vast stretches of inner London, the planners in 1945 had a *tabula rasa* offered to them, on which to make good this deficiency, to raise the twentieth-century equivalent of Wren's spires. Elevation has indeed been achieved, but the point of elevation – which is to soar, and soaring, to lift the human heart and spirit – has been sadly lost. Modern architecture, a congregation of tower blocks, true skyscrapers, can achieve that, as any newcomer who has walked the canyons of Manhattan in electric delight will know, but the London version, with a few honourable exceptions, consists of blunted fingers or knobbly fists prodding clumsily at the upper air, an air only too lucid following the Clean Air Act. Instead of spires, we have excrescences hundreds of feet in the air housing machinery or water-tanks, and at ground level the scythe-like draughts of the tower blocks' 'micro-climate'. Meanwhile the tower blocks, as they thicken across the City's skyline, gradually obliterate St Paul's.

TOP **Oskar Kokoschka**, *Tower Bridge III* from a set of
nine lithographs, *London from the River Thames*, 1967.

ABOVE **Oskar Kokoschka**, *View of London with the Houses
of Parliament*, 1967. This very late canvas by Kokoschka
was possibly painted from the top of the Shell Mex Tower.

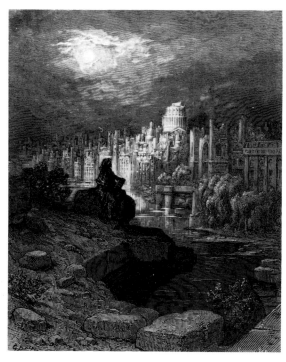

Almost at the beginning of this survey, Matthew Paris established the key elements that serve to define London: the Tower, St Paul's and Westminster, linked by the Thames. All have continued to feature prominently in artists' views through the centuries. The Tower perhaps must now sink from sight, and be replaced by the silhouette of Tower Bridge. The Abbey became much more picturesque with the addition of Hawksmoor's towers in the mid-eighteenth century, only to become agglomerated into Barry's dominating ensemble of the new Houses of Parliament in the mid-nineteenth century. St Paul's, the great Gothic church soaring from the early panoramas, giving way to the completely different but even more dominant surge of Wren's great dome, is only now threatened with absorption. But the Thames runs on as ever, constantly rediscovered by artists if neglected by Londoners. Up river at Hammersmith and Chiswick, Victor Pasmore celebrated it in hazy melting idylls, before abandoning landscape for pure abstraction (pp. 136–7). Kokoschka we have seen returning to it again in the late Sixties.

The river, almost alone, has offered to artists the panoramic view, a grand sweep of metropolitan scale, the kind of vistas they have found more copiously available in the boulevards and monuments of Paris. Paris has always had that sense of style, showing herself off to best advantage. Henry James diagnosed as 'the most general characteristic of the face of London', 'the absence of style, or rather of the intention of style'. And in fact it took the Blitz to reveal St Paul's in the splendour of its totality; now we are back to tracking it in glimpses from

the depths of the City streets as it sinks from sight. Doré's and Jerrold's pilgrimage through London in about 1870 ended with a glimpse of nemesis, the doom that must overtake all civilizations, all great capitals, in the end. To illustrate it Doré took Macaulay's vision of a London shattered like Greece and Rome, 'when some traveller from New Zealand shall, in the midst of a vast solitude, take his stand on a broken arch of London Bridge, to sketch the ruins of St Paul's'. But not yet: even though the London Bridge that Doré knew has gone (to be rebuilt in Arizona), the new bridge survives. And though one may recoil from the incidental ugliness, one stays, or leaves only to return. Dr Johnson noted over two hundred years ago that he who was tired of London was tired of life. A century later, Henry James outlined 'a tremendous list of reasons why London should be insupportable', and yet, had to admit, 'London is on the whole the most possible form of life.' We are almost a century on from James and our admission might be even more guarded, but the sense of excitement, of the possible, can still tingle in the air of London. The image that for the moment conveys for me most poignantly that sense of the possible, of day dawning with a new surmise, is a modest canvas by one of the subtlest, most English, of twentieth-century painters, Mary Potter. It was painted in 1948, at the bleak period of the 'ersatz-victory' when England still was being rationed and peace was failing to provide its promised bliss: yet, on a misty winter morning in an upper room in Harley Street, looking over a burgeoning hyacinth on the window-sill to a murky sky articulated by chimney-pots, it is instinct with the pleasure of being alive at the heart of London.

Acknowledgements

My first vision of this book was of a glorious comprehensive totality: of London within and without as seen by artists through the centuries. The constraints of the possible, in publishing terms, soon whittled that ambition down. For reasons of space I have had to focus, especially from the mid-eighteenth century onwards, on the visions of the finest artists, so that the work of many artists, who if not 'great' nevertheless were of gifted and charming individuality, is not even mentioned. For the same reasons I have had to narrow my subject down to the fabric of London, though not, I hope, pedantically so. It remains for other books to be compiled on, for example, artists' recordings of London life, London interiors and countless more specialized facets of the city. Even of the London that never was: the unrealized designs of Inigo Jones, Webb, Hawksmoor, Nash, C.R.Cockerell, and the optimistic utopias of the post-blitz planners. The latter part of the book is a very personal choice, and those who know London and its artists will inevitably find some of their favourites omitted. I hope nevertheless that this selection, incomplete though it be, will give pleasure to those who love London.

A complete list of all those persons and works to whom I am obviously and most gratefully indebted would be presumptuous in such a book as this, but I would like to record a minute selection of books on which I have especially drawn:

W.Baron, *The Camden Town Group*, London, 1979

A.Bowness, *The Impressionists in London* (Arts Council Exhibition Catalogue), London, 1973

D.B.Brown, *Catalogue of the Collection of Drawings in the Ashmolean Museum*, Vol. IV, Oxford, 1982

J.Hayes, *London: A Pictorial History*, London, 1969

J.Hayes, *Catalogue of the Oil Paintings in the London Museum*, London, 1972

A.M.Hind, *Wenceslaus Hollar and his View of London and Windsor in the 17th Century*, London, 1922

A.M.Hind, 'Rembrandt's Supposed Drawing of Old St Paul's' in the *Burlington Magazine XVII*, 1910, pp. 334–40

J.G.Links, *Townscape Painting and Drawing*, London, 1972

J.G.Links, *Canaletto and his Patrons*, London, 1977

P.J.A.Lubbock, *The Halls of the Livery Companies of the City of London*, London, 1981

R.Paulson, *Hogarth's Graphic Works*, New Haven, 1965

R.Paulson, *Hogarth: His Life, Art and Times*, New Haven, 1971

DP

While this book was at the press, F. Barker's and R. Hyde's *London as it might have been* was published, which excellently covers one of the themes mentioned above.

List of Illustrations

The author and publishers would like to thank the individuals, museums, collections and agencies mentioned below, by whose kind permission the illustrations are reproduced.

70 **Thomas Rowlandson** (1756–1827),
(below) *Vauxhall Gardens*, exh. 1784
watercolour, 19 × 29½ ins
Victoria and Albert Museum, London

72 **J. M. W. Turner** (1775–1851), *The
Burning of the Houses of Parliament*,
1834
watercolour, 9¼ × 12¼ ins
British Museum, London (Photo:
Michael Holford)

73 **J. M. W. Turner** (1775–1851), *The
Burning of the Houses of Parliament, 16
October 1834*, exh. 1835
oil, 36¼ × 48½ ins
Philadelphia Museum of Art: The John
H. McFadden Collection

74 **Thomas Malton** (1748–1804) *The
Mansion House*, 1783, from *A
Picturesque Tour through London
and Westminster*, 1792
aquatint, 13 × 19 ins
Guildhall Library, City of London

76–7 **John Constable** (1776–1837), *A View
of London with Sir Richard Steele's House*,
exh. 1832
oil, 8¼ × 11¼ ins
Paul Mellon Collection, Upperville,
Virginia

78 **J. M. W. Turner** (1775–1851), *The
(above) Pantheon, the Morning after the Fire*,
1792
watercolour, 15½ × 20½ ins
British Museum, London

78 **John Constable** (1776–1837), *Fire in
(centre) London from Hampstead*, 1826?
oil, 3¾ × 6 ins
Paul Mellon Collection, Upperville,
Virginia

78 **John Constable** (1776–1837), *The
(below) Opening of Waterloo Bridge or Whitehall
Stairs, 18 June 1817*, exh. 1832
oil, 53 × 86½ ins
Private Collection (Photo: Bridgeman
Art Library)

80 **T. H. Shepherd** (1793–1878), *Regent
Circus*, 1822
aquatint, 15½ × 19¼ ins
British Museum, London

82 **T. Shotter Boys** (1803–74), *The Tower
of London and the Mint* from *London as it
is*, 1842
lithograph, 8 × 17 ins
Guildhall Library, City of London

82–3 **William Daniell** (1769–1837), *A View
of the East India Docks*, 1808
aquatint, 16 × 30½ ins
Guildhall Library, City of London
(Photo: Bridgeman Art Library)

83 **George Scharf Sr.** (1788–1860),
Montague House, 1848–9
watercolour, 9¼ × 12¼ ins
British Museum, London

84 **James Hakewill** (1778–1893), *The
Monkey House in the Zoological Gardens*
from *A Series of Ten Views in the
Southern Portion of the Gardens of the
Zoological Society in Regent's Park*, 1831
lithograph, 8¹¹⁄₁₆ × 12½ ins
Yale Center for British Art, Paul Mellon
Collection

85 **C. R. Stanley** (c. 1790–1868), *The
Strand, Looking Eastwards from Exeter
Change*, c. 1824
oil, 30 × 27⅛ ins
Museum of London

86 **Louis Pierre Spindler** (1800–89),
London Interior, 1834
oil, 20¾ × 17 ins
Musée des Beaux Arts, Strasbourg

87 **Jacques-Laurent Agasse** (1767–1849),
Landing at Westminster Bridge,
1817–18
oil, 13¾ × 21 ins
Oskar Reinhart Collection, Winterthur

88 **Carl Hartmann** (1818–c. 1857),
Nelson's Column from *A London
Sketchbook*, 1847
drawing, 5 × 7 ins
Fitzwilliam Museum, Cambridge

89 **Eugène Lami** (1800–90), *View of
London*, c. 1850
watercolour, 6¼ × 10½ ins
Hazlitt, Gooden & Fox, London

90 **John Orlando Parry** (1810–97),
London Street Scene with Posters, 1835
oil, 28 × 41 ins
Alfred Dunhill Collection (Photo: E. T.
Archive)

91 **I. J. Borgnis** (active mid-19th c.), *The
Metropolitan Baths, Shepherdess Walk,
Hoxton*, c. 1845
oil, 24¼ × 24⅞ ins
Museum of London

92 **George Cruikshank** (1792–1878),
*London going out of Town or The March of
Bricks & Mortar*, 1829
etching, 6 × 10 ins
Guildhall Library, City of London

93 **John C. Bourne**, *Building the Retaining
Wall, Camden Town* from *Drawings of the
London and Birmingham Railway*, 1839
lithograph, 19¾ × 16¼ ins
Science Museum, London

94 **J. McNeill Whistler** (1834–1903), *Grey
and Silver: Chelsea Wharf*, c. 1864–8
oil, 24¼ × 18⅛ ins
National Gallery of Art, Washington
D.C.: Widener Collection

95 **J. McNeill Whistler** (1834–1903),
*Nocturne in Black and Gold: The Falling
Rocket*, 1874
oil, 23¾ × 18⅜ ins
Detroit Institute of Art: Dexter M. Ferry
Jr. Fund

96 **J. McNeill Whistler** (1834–1903), *The
'Adam and Eve', Old Chelsea*
etching, 6⅞ × 11⅞ ins
British Museum, London (Photo:
Courtauld Institute, London)

97 **Alfred Sisley** (1839–99), *View of the
Thames*, 1874
oil, 12½ × 16½ ins
Private Collection (Photo: A. C. Cooper)

98 **Charles Daubigny** (1817–78), *St Paul's
from the Surrey Side*, 1873
oil, 17½ × 32 ins
National Gallery, London

99 **François Bonvin** (1817–87), *Waterloo
Bridge*, 1871
watercolour
Louvre, Paris (Photo: Réunion des
Musées Nationaux)

100 **Ford Madox Brown** (1821–93), *Heath
Street, Hampstead*, 1852–5
oil, 9 × 12⅛ ins
City Art Gallery, Manchester

101 **Sidney Starr** (1857–1925), *A City
Atlas*, 1888–9
oil, 24 × 20 ins
National Gallery of Canada, Ottawa:
Gift of the Massey Foundation, 1946

102 **Camille Pissarro** (1831–1903),
(above) *Lordship Lane Station, Lower Norwood*,
1871
oil, 17¼ × 28¾ ins
Courtauld Institute Galleries, London:
Courtauld Collection

102 **Camille Pissarro** (1831–1903), *The
(centre) Crystal Palace, London*, 1871
oil, 19 × 29 ins
Art Institute of Chicago: Gift of Mr and
Mrs B. E. Bensinger

102 **Claude Monet** (1840–1926), *Green
(below) Park*, 1870–1
oil, 13½ × 28½ ins
Philadelphia Museum of Art:
Purchased by the W. P. Wilstach Fund

104–5 **Henry Pether** (active 1828–65),
*Northumberland House and Whitehall
from the North Side of Trafalgar Square by
Moonlight*, c. 1861–7
oil, 24 × 36¼ ins
Museum of London

106 **James Tissot** (1836–1902), *London
(left) Visitors*, 1874
oil, 24¼ × 17¾ ins
Toledo Museum of Art: Edward
Drummond Libbey, 1951

106 **James Tissot** (1836–1902), *Going to the
(right) City*, 1879
oil, 16 × 7 ins
Sotheby Parke Bernet & Co., London

107 **Gustave Doré** (1832–83), *Une Rue
(above) Occupée*, c. 1879
drawing, 22 × 14¾ ins
Private Collection

107 **Gustave Doré** (1832–83), *Over
(below) London – By Rail* from *London: A
Pilgrimage*, 1872, by Blanchard Jerrold
and Gustave Doré
engraving
Guildhall Library, City of London

108–9 **John O'Connor** (1830–89), *St Pancras
Hotel and Station from Pentonville Road:
Sunset*, 1884
oil, 36⅛ × 40⅜ ins
Museum of London

112 **Camille Pissarro** (1830–1903), *Bedford
Park, Bath Road, London*, 1897
oil, 21¼ × 25½ ins
Ashmolean Museum, Oxford

114–15 **Claude Monet** (1840–1926), *Waterloo
Bridge, Grey Day*, 1903
oil, 25½ × 39⅜ ins
National Gallery of Art, Washington
D.C.: Chester Dale Collection

116 **Atkinson Grimshaw** (1836–93), *View
of Heath Street by Night*, 1882
oil, 14½ × 21⅛ ins
Tate Gallery, London

118 **André Dérain** (1880–1954), *The Houses of Parliament*, 1905–6 oil, $31\frac{1}{8} \times 38\frac{5}{8}$ ins Pierre Lévy Collection, Troyes (Photo: Bridgeman Art Library) © A.D.A.G.P., Paris, 1982

119 **Claude Monet** (1840–1926), *The Houses of Parliament*, 1903 oil, $32 \times 36\frac{3}{8}$ ins Metropolitan Museum of Art, New York: Bequest of Julia W. Emmons (1956)

121 **Raoul Dufy** (1877–1953), *The Coronation of King George VI*, 1937 watercolour, 16×26 ins Private Collection (Photo: Hans Hinz, Switzerland) © S.P.A.D.E.M., Paris, 1982

122 **Malcolm Drummond** (1880–1945), *St James's Park*, 1912 oil, $28\frac{1}{2} \times 35\frac{1}{2}$ ins Southampton Art Gallery

123 **Harold Gilman** (1876–1919), *A London Street in Snow*, 1917 oil, $19\frac{1}{2} \times 15\frac{1}{2}$ ins Private Collection (Photo: Sotheby Parke Bernet & Co., London)

124 **Oskar Kokoschka** (1886–1980), *London, Large Thames View I*, 1926 oil, $35\frac{1}{4} \times 51\frac{1}{4}$ ins Albright-Knox Art Gallery, Buffalo, New York: Room of Contemporary Art Fund, 1941. © A.D.A.G.P., Paris, 1982

125 **Chiang Yee**, *Umbrellas under Big Ben*
(left) for *The Silent Traveller in London* 1938 drawing Victoria and Albert Museum, London

125 **C. R. W. Nevinson** (1889–1946), *Wet*
(right) *Evening, Oxford Street*, 1919 lithograph, $29\frac{1}{4} \times 19$ ins Private Collection

126 **C. R. W. Nevinson** (1889–1946), *The Towpath, Camden Town, by Night*, c. 1912 oil, 30×22 ins Ashmolean Museum, Oxford

127 **Algernon Newton** (1880–1968), *Paddington Basin*, 1925 oil, 27×49 ins Brighton Pavilion, Art Gallery and Museum

129 **Claude Monet** (1840–1926), *Leicester Square by Night*, 1918? oil, $31\frac{1}{2} \times 25\frac{1}{4}$ ins Galerie Beyeler, Basle

130 **Harold Gilman** (1876–1919), *Battersea*
(left) *Bridge* (or Hammersmith Bridge) drawing, $7\frac{3}{4} \times 11\frac{1}{2}$ ins Private Collection

130 **Walter Sickert** (1860–1942), *Maple*
(right) *Street*, c. 1920 etching, $7\frac{3}{4} \times 5$ ins London Borough of Islington

131 **Spencer Gore** (1878–1914), *Mornington Crescent*, 1912 oil, 16×20 ins Private Collection (Photo: Christie Manson & Wood, London)

132 **Charles Ginner** (1878–1952), *Piccadilly Circus*, 1912 oil, 32×26 ins Tate Gallery, London (Photo: Christie Manson & Wood, London)

133 **Walter Sickert** (1860–1942), *Queen's*
(above) *Road, Bayswater, Station*, c. 1916 oil, 25×30 ins Courtauld Institute Galleries, London (Photo: Bridgeman Art Library)

133 *London Transport Underground Map*.
(below) 1964 London Transport Executive

134 **Robert Bevan** (1865–1925), *From the Artist's Window*, 1915–16 oil, $24\frac{7}{8} \times 29\frac{7}{8}$ ins Leicester Art Gallery

135 **C. R. W. Nevinson** (1889–1946), *Amongst the Nerves of the World*, c. 1930 oil, $30\frac{1}{8} \times 20$ ins Museum of London

136–7 **Victor Pasmore** (b. 1908), *The Quiet River: The Thames at Chiswick*, 1943–4 oil, 30×40 ins Tate Gallery, London

138 *'Fogged'* from *Punch*, 7 December 1904 drawing Private Collection

139 **R. Howard Penton** (1892–1960),
(right) *Skinners' Hall*, 1903 drawing, $11\frac{1}{2} \times 8$ ins Private Collection (Photo: Jones, Lang and Wootton)

139 **Muirhead Bone** (1876–1953), *St*
(left) *Martin-in-the-Fields* from *London Echoing* by James Bone, 1948 etching Victoria and Albert Museum, London

140 **John Piper** (b. 1903), *Christ Church, Newgate Street, after its Destruction in 1940*, 1941 oil, $30\frac{1}{4} \times 25\frac{3}{4}$ ins Museum of London

141 **Graham Sutherland** (b. 1903), *Devastation: an East End Street*, 1941 gouache, $25\frac{1}{2} \times 44\frac{3}{4}$ ins Tate Gallery, London

142 **David Jones** (1895–1974), *Brockley Gardens, Summer*, 1925 drawing, $20\frac{1}{2} \times 15\frac{3}{4}$ ins Anthony d'Offay Gallery, London

143 **Unknown Artist**, *London Underground Poster: Golders Green*, 1908 London Transport Executive

144 **Charles Ginner** (1878–1952), *Emergency Water-Storage Tank*, 1941–2 oil, 27×20 ins Tate Gallery, London

145 **Christopher Hall** (b. 1930), *Tolmers Square, St Pancras*, 1954 oil, $25\frac{3}{4} \times 17\frac{1}{16}$ ins Museum of London

146 **J. Hodgson Lobley** (1878–1954), *Outside Charing Cross Station, July 1916*, 1919 oil, 81×121 ins Imperial War Museum, London

148 **Muirhead Bone** (1876–1953), *Piccadilly Circus*, 1915 from *London Echoing* by James Bone, 1948 etching Victoria and Albert Museum

149 **David Bomberg** (1890–1957), *Evening*
(above) *in the City of London*, 1944 drawing, $18\frac{1}{4} \times 23\frac{1}{4}$ ins Ashmolean Museum, Oxford

149 **Henry Moore** (b. 1898), *Group of*
(below) *Shelterers during an Air Raid*, 1941 drawing, $15 \times 21\frac{7}{8}$ ins Art Gallery of Ontario, Toronto

150 **L. S. Lowry** (1887–1976), *Deptford Power Station from Greenwich*, 1959 oil, 20×30 ins National Maritime Museum, Greenwich

151 **Oskar Kokoschka** (1886–1980),
(above) *Tower Bridge III* from *London from the River Thames*, 1967 lithograph, $25 \times 35\frac{1}{4}$ ins Private Collection (Photo: Marlborough Fine Art, London, Ltd.) © A.D.A.G.P., Paris, 1982

151 **Oskar Kokoschka** (1886–1980),
(below) *View of London with the Houses of Parliament*, 1967 oil painting, $36 \times 53\frac{3}{4}$ ins Private Collection (Photo: Marlborough Fine Art, London, Ltd.) © A.D.A.G.P., Paris, 1982

152 **Gustave Doré** (1832–83), *The New Zealander* from *London: A Pilgrimage*, 1872, by Blanchard Jerrold and Gustave Doré engraving Guildhall Library, City of London

153 **Mary Potter** (b. 1900), *Misty Morning*, 1948 oil painting, 20×24 ins R. Grenfell Esq., London

END PAPER **Wenceslaus Hollar** (1607–77), *The East Side of Southwark towards Greenwich* (detail). See p. 29 in List of Illustrations.

Index